# GEISHA

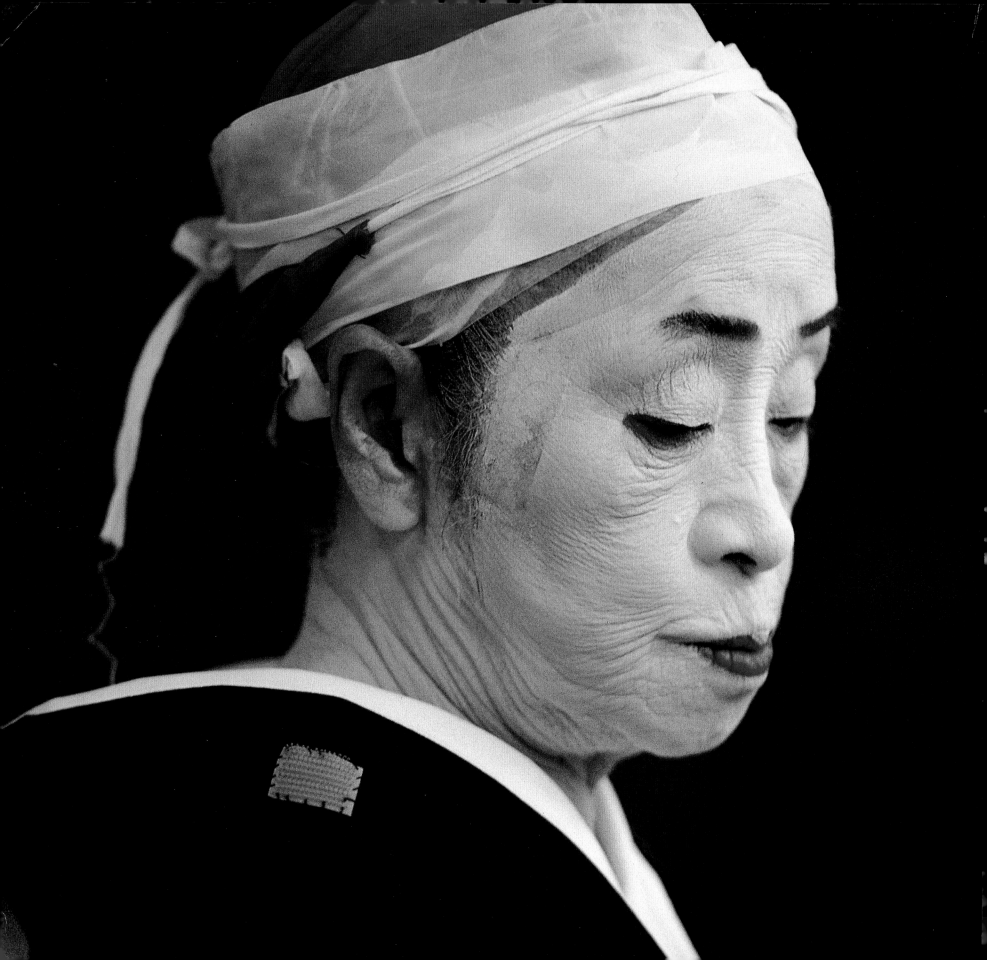

# GEISHA

## The Life, the Voices, the Art

## JODI COBB

 ALFRED A. KNOPF    NEW YORK    2000

I have changed the names of the geisha who were so generous with their time and their stories, and welcomed me into their lives during the last three years. To a Western mind, having your photograph published but your name changed may seem a contradiction. But it is a perfect example of the dichotomy at the heart of Japanese society—the gap, and sometimes chasm, between *tatemae* and *honne*, between your public face and your private inner thoughts.

Copyright © 1995 by Jodi Cobb
All rights reserved under International and Pan-American Copyright Conventions. Published in the United States by Alfred A. Knopf, Inc., New York, and simultaneously in Canada by Random House of Canada Limited, Toronto. Distributed by Random House, Inc., New York.

Grateful acknowledgment is made to the following for permission to reprint previously published material:
*Oxford University Press:* Excerpt of poem by Ihara Saikaku, from *The Floating World in Japanese Fiction* by Howard Hibbett, copyright © 1959 by Oxford University Press. Reprinted by permission of Oxford University Press, Oxford, England.
*Charles E. Tuttle Co., Inc.:* Poem (p. 103) from *Yoshiwara: The Pleasure Quarters of Old Tokyo* by Stephen and Ethel Longstreet, copyright © 1970 by Stephen and Ethel Longstreet; the geisha songs "She sulkily pretends to sleep . . .," "I bathed my snow skin . . .," "The night is black . . .," "I know she is light and faithless . . .," "Visitor this evening . . ." from *Comrade Loves of the Samurai and Songs of the Geisha* by E. Powys Mathers (Tokyo: Charles E. Tuttle Co., Inc., 1972); "Longing, Longing," "Spring Wind Whispers," "Waiting Anxiously," "Your Heart Flip-flops" (pp. 20, 32, 77, 92), from *Ko-uta: Little Songs of the*

*Geisha World* by Liza Crihfield, copyright © 1979 by Charles E. Tuttle Co., Inc. Reprinted by permission of Charles E. Tuttle Co., Inc., Tokyo, Japan.

Library of Congress Cataloging-in-Publication Data

Cobb, Jodi.
    Geisha / Jodi Cobb.—1st ed.
        p.    cm.
    Includes bibliographical references (pp. 78–79).
    ISBN 0-679-43774-6
    ISBN 0-375-70180-X (paperback)
    1. Geishas.    2. Geishas—Pictorial works.    I. Title.
GT3412.C63    1995
306.74'2'0952—dc20                                    94-37663
                                                                    CIP

Manufactured in Singapore

Published October 27, 1998
Seond Printing, April 2000

For my parents

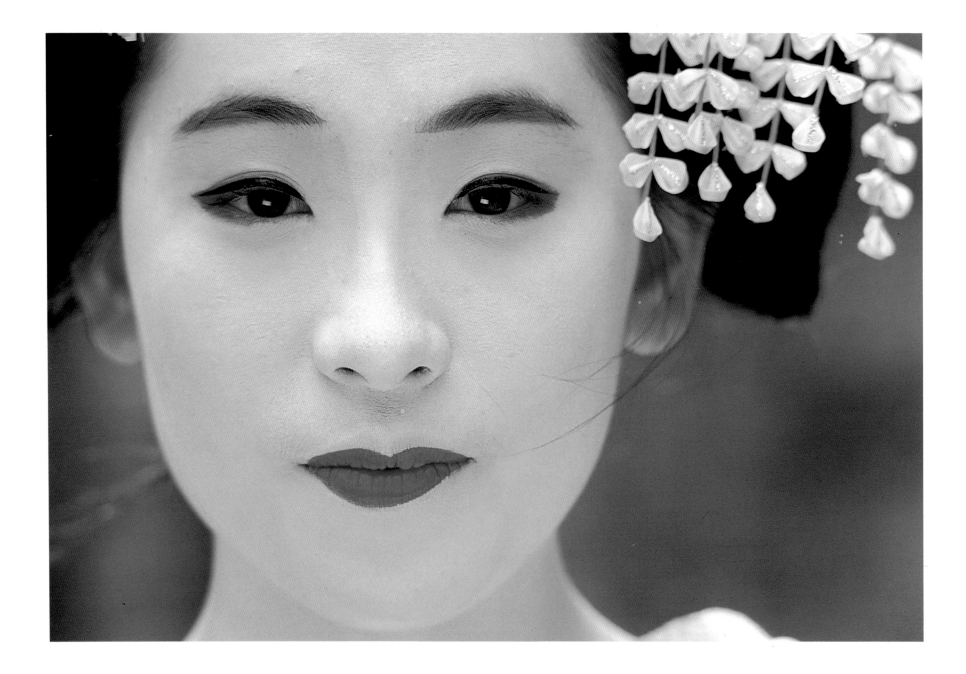

# INTRODUCTION

*by Ian Buruma*

THE GEISHA, like the Chicago gangster or the English gentleman, is an emblem, something everyone, however uninformed about Japan, can recognize. Some Japanese find this irritating. They call this emblematic, foreign view of the country the "Fujiyama/geisha view." Sometimes they round out the stereotype by adding the *sakura*, or cherry blossom.

To simply reproduce an emblem, such as the geisha, as a pretty postcard image of Japan, would not be difficult. But to penetrate the surface, to enter into the closed world that exists behind the image of the geisha, and to show her in a way most of us have never seen before, that requires talent, persistence, and sensitivity of the highest order. That is why Jodi Cobb's photographs are a revelation: she has wrung something unique out of a cliché; she has brought a stereotype to vivid, well-defined life.

In Chinese or Japanese artistic tradition, by the way, there is nothing wrong with clichés as such. Japanese artists love cherry blossoms. And Chinese artists for centuries have painted stereotyped scenes, usually in the style of an old master. But the art does not lie in the subject portrayed. The true test of skill is to redefine the familiar.

Jodi Cobb has not done this in an obvious way. Consider, for example, the pictures of geisha dancing onstage. A lesser artist might have tried to break up the formalism of the geisha's art by distortion, weird angles, odd lenses. Cobb's pictures are straightforward. The performances are recorded from the point of view of the audience, rather than of some imaginary fly peering down from the backdrop. It is precisely from the center of the auditorium that we see the geisha at her most theatrical, most stylized. Any artifice on the part of the photographer would have diminished this effect. Like an eighteenth-century Japanese woodblock artist, Cobb has caught the performers in full pose.

Posing is an integral part of the geisha's performance, as indeed, of all traditional Japanese dance and acting. In classical—and much modern—Japanese theater, dance and acting are in fact the same thing. When Kabuki developed in the seventeenth century, its earliest female performers, who in actuality were also prostitutes, danced on stages erected by the riverside in Kyoto, very near some of the geisha establishments photographed by Cobb. The essence of Japanese dance-theater lies in the *kata*, or dramatic posture, which wraps up climactic scenes. Woodblock prints of Kabuki usually show an actor doing a *kata*: a warrior flinging out his arms and legs, rolling his eyes, trembling with emotion; a courtesan (or prostitute) bending her knees, arching her back, in a classic pose of erotic submission.

Woodblock prints often single out a star performer, isolating him or her from the rest of the action. But a *kata* is rarely performed in isolation. Especially in the case of women dancing, an individual pose is generally part of a larger scene, rather like a *tableau vivant*. In Cobb's photographs, the geisha look as disciplined as dancers in Busby Berkeley routines, except that Japanese dancers never smile. Insofar as this is possible in still pictures, Cobb shows the peculiar dynamism of Japanese dance, which comes, not from fast or fluid action, but from the tension between motion and absolute stillness.

The connection between stage acting and geisha entertainment goes deeper than the rather staid classical dance performances of today suggest. Not only were the first Kabuki actresses prostitutes, but so, subsequently, were the male actors who gradually took their place in female roles. Rich men (and sometimes women) would have the actors perform for them, and then ask them to stay on for more private entertainments. The brothels were located in the same licensed

areas as the theaters, and there was a constant *va et vient*—literally and artistically—between the two. Notorious love affairs between prostitutes and clients became the theme of many Kabuki plays, and the women in the brothels and teahouses copied the styles pioneered onstage. The fashion for critical booklets that assessed actors' performances was preceded by similar booklets reviewing the attractions of star courtesans and prostitutes.

The closest thing in the theater of the eighteenth and nineteenth centuries to the high-class geisha was the *onnagata*, the male actor of female roles. As is still true of the geisha today, the *onnagata*'s art is highly artificial—pure theater, one might say. It was never the idea to impersonate women realistically, but rather to express an idealized concept of femininity through highly stylized female mannerisms and behavior. This cannot be done by relying on physical charms. Indeed, the very absence of natural female beauty can be said to have helped bring the *onnagata*'s art to perfection. In the words of a famous eighteenth-century *onnagata*, "the ideal woman can only be expressed by an actor." And one may well say the same of the ideal geisha: a lady of a certain age, whose skill in performance, rather than her beauty, is her prime asset. Like the greatest *onnagata*, who can still play young lovers well into their eighties, the older geisha bear the patina of time.

Some of Cobb's finest portraits are of elderly geisha whose sagging mouths and wrinkled skin cannot be masked, but indeed are emphasized by their thick white makeup. The young geisha, and the even younger *maiko* (apprentice geisha) are beautiful, to be sure. The *maiko* is a stylized vision of unblemished virgin youth. In one of Cobb's most striking *maiko* portraits, the subject looks down modestly. Her skin has the texture and pinkish-white color of a delicate cherry blossom. In real life she might be a pimply adolescent, but in makeup and costume she is a picture of innocence before the fall.

The portraits of young geisha are less demure. The women look straight into the camera; they have already tasted life. Their skins are still smooth, but a certain individuality is beginning to shine through. Their eyes and mouths, however carefully painted, are, if not quite flirtatious, certainly knowing. They have the confidence of both beauty and experience. Nonetheless, it is the older women who look most interesting. Cobb has photographed them without their wigs; their hair is plastered down with tight bandages. The white makeup and crimson lipstick have been applied. There is nothing either innocent or coquettish about them, although, like elderly *onnagata*, they could probably still play any role to perfection. Instead, there is a kind of dark wisdom in their hooded eyes. Nothing human is strange to these women. To some this has lent an expression of tolerance and kindness; to others, a look of latent (or perhaps not so latent) cruelty.

Cobb's portraits show that the geisha is not only an artist, but also, so to speak, her own canvas. Like the puppeteers of the Bunraku theater, whose puppets' jerky movements first inspired the dramatic poses of Kabuki actors and courtesans, the geisha makes no effort to hide the art of her performance. It is on show to be admired. Cobb's pictures clearly demonstrate this: the photographer scrutinizes the mechanics behind the work of art. Actually, "behind" is not the right word, for the artifice is up front: the geisha is the puppeteer and the puppet at the same time.

We see the white and pink pigment being applied to the geisha's skin in close-up. We see a stubbly artisan's hand blacken the eyebrow of a *maiko*, much as a painter or calligrapher brushes his ink on a piece of rice paper. We see the crimson half-moon of a mouth, with tiny rivulets of red filling the tiny cracks. And we see mirrors, of all shapes and sizes. In these mirrors we see, among other things, a geisha, in dance costume, dabbing her forehead in a backstage dressing room; a vessel filled with lip-rouge, a bunch of red flowers, a hand stubbing out a cigarette; two hands applying cream to a hidden face, beside an altar with photographs of a deceased old man (a father? a patron?); a young geisha being fitted into her red undergarments in a dressing room cluttered with wig-boxes, a television set, piles of kimonos.

These pictures of backstage life stand in complete contrast to the formal photographs of the geisha onstage. The former are frenetic, messy, busy, detailed, not at all pretty, expressing perfectly the hectic atmosphere of dressing rooms (like kitchens) where performances are prepared. It is in these pictures that the girls and women clearly manifest individual personalities. Here, before they appear onstage, they laugh, they hug each other, they chat. Some look apprehensive, or expectant, or simply tired. Others read astrology charts in women's magazines. It is an atmosphere halfway between a girls' boarding school and a professional theater.

In these pictures, unlike those of the dance performances, the women often look isolated, lonely. They convey the sadness of the world of a professional performer. People who spend their lives dressing up, playing roles, "selling dreams," can only snatch moments to be themselves. For the geisha in this book, Cobb's camera was a silent witness to such moments. And through the same discreet, sympathetic eye, we catch glimpses of young, individual personalities gradually being transformed through white paint, powder and crimson lipstick into a stylized image of the ideal woman.

Ideals change with time, of course. As Jodi Cobb has observed in her text, the modern geisha is not at all the same woman as her eighteenth- or nineteenth-century sister. Premodern female entertainers formed a complex hierarchy, from the lowest streetwalker to the most refined courtesan, but most, in one way or another, engaged in prostitution. The word *geisha* was not used until the seventeenth century. The first entertainers to go by that name were in fact men, who amused the patrons of teahouses and brothels. But female geisha soon became more practiced in the arts of music, song and dance than their male counterparts, and were, moreover, accomplished enough in the amorous arts to threaten the livelihoods of licensed prostitutes. So a rule was instituted forbidding geisha to sleep with clients in the teahouses. Geisha, however, found ways to get around this prohibition, and they remained part of a world that was fashionable, erotic, theatrical,

but not in any sense classical. It was not until around 1870 that both Kabuki theater and geisha became staples of Japanese tradition.

In 1872, Ichikawa Danjuro IX, the greatest Kabuki actor of his time, dressed up in white tie and tails and made a speech (quoted in Thomas Rimer's book *Toward a Modern Japanese Theatre*): "The theater of recent years," he said, "has drunk up filth and smelled of the coarse and the mean. It has fallen into mannerisms and distortions and has been steadily flowing downhill. . . . I am deeply grieved by this fact and in consultation with my colleagues I have resolved to clean away the decay."

Kabuki, from then on, became the academy. And in time the same would be true of the most highly trained geisha. Geisha's double role as artistes and high-class prostitutes may have lasted, in some cases, until World War II, but certainly not after it. Bar hostesses, hot-springs "geisha," massage parlor girls and the like took over the lower end of the sexual market, and expensive call girls came to operate as the upper echelon. Today's geisha do not sell sex, at least not cheaply, or to any bidder; they have patrons, not tricks.

The geisha, like Kabuki, Bunraku, No, and indeed, *Nihonga*, or Japanese-style painting (as opposed to *Yoga*, Western-style painting), has become, as already noted, an emblem of Japaneseness. One method of preserving the forms of what was once merely fashionable and has since become tradition, has been to insist on drawing a clear line between "Western" and "Japanese." *Yoga* not only are painted in oil instead of ink but are often of such typically Western subjects as Parisian streets or women in European dress, whereas *Nihonga* commonly depict geisha, or cherry blossoms, or Mount Fuji. This distinction between "Japanese" and "Western" is now itself one of the clichés of twentieth-century Japan.

Again Jodi Cobb's sharp eye has managed to find gems on well-trodden paths. Some pictures present straightforward contrasts. Two posters are pinned side by side on a wooden wall: one shows Warren Beatty about to kiss his leading lady, a perfect image of modern, Western romance; the other is a picture of a *maiko*, performing a Kyoto

dance, dressed in kimono, arranged to reveal the nape of her whitened neck. Then there is the traditional wax-paper crimson umbrella, with a red Coca-Cola vending machine in the background. But the picture in which Cobb may have most beautifully captured the atmosphere of modern Japan is the one of a smiling geisha dressed like an Edo Period courtesan, parading in front of a crowd of onlookers and photographers. The white-and-black of a paper parasol, held high above her head, is reflected in what looks like a limpid pond in a Japanese garden, but is in fact the roof of a gleaming limousine. Here East and West are not so much in contrast as parts of the same modern Japanese world.

That Japan, despite the speed of modernization (or Westernization, if you prefer), has preserved so many of its artistic traditions, is of course remarkable. Perhaps this could not have been done without the attempt to maintain a rigid distinction between native tradition and modern, alien imports. But the unfortunate result of this dividing line has been the gradual fossilization of the country's premodern culture. Kabuki cannot be endlessly updated, adapted and reinterpreted in the way Shakespeare's plays are, or at any rate not nearly so easily. Classical Japanese culture, including the arts of the geisha, achieved its final, most polished form in the latter half of the nineteenth century.

Yet it is possible to exaggerate the purity of Japanese tradition. Many foreign imports—"Auld Lang Syne," breaded pork cutlets, whiskey and water—have become as Japanese as . . . the geisha. Cobb's photographs show how the borderline between Western and Japanese, old and new, is not as clearcut as one might think. Some geisha parties take place in the tatami rooms of traditional Japanese restaurants, but some are in Western-style establishments: expensive bars with leather couches and wood-paneled walls, and whiskey bottles and ice buckets on the tables. The only traditional element here is the geisha's kimono. As if to underline the modernity of such scenes, in contrast to the traditional stage performances, Cobb has often tilted her camera at odd angles and used long exposures to produce blurred movements which add a sense of speed and excitement.

There is nothing stilted or even genteel about these night scenes. A female hand slipping a pile of ten-thousand-yen notes into the kimono of another, while a male guest sits slumped over the table, presumptively drunk, makes it quite plain what fuels these entertainments. Not that anything so crass as money bills would ever change hands at the most elegant geisha parties—money would not even be mentioned. Even in the best establishments, however, formality tends to break down with drink. Conversations are full of sexual innuendo, and as a party progresses, the games played by geisha and clients become not only raucous but, to a Western sensibility, remarkably childish, as though relaxation necessarily implies regression. Admiral Yamamoto Isoroku, the man who planned the attack on Pearl Harbor, was a great lover of geisha parties. In a good mood he would do handstands, or tricks with food.

Some of Cobb's pictures of geisha and their clients convey an air of indulgent mothers coddling wayward sons: in the world of the geisha, boys will literally be boys. This throws an interesting light on the most tenacious cliché of all: the submissive Japanese woman. In the fantasies of many Western men, the phrase "geisha girls" conjures up images of almost doll-like complaisance. The Japanese idea of the geisha is rather different. Even in premodern Japan, the geisha was far from a mere plaything. The idea of the geisha, then as now, has always been much more complex.

A Japanese actor once told me that all actors are masochists. He was being extreme, but I could see his point: Playing a role to feed the fantasies of an audience can be a form of masochism. Yet it is also a source of power. The one who manipulates another person's dream exercises thereby a degree of control. This is also true—indeed, especially true—if the manipulator sacrifices or suppresses his or her own desires. Japanese men have long idealized, in Kabuki plays as well as the movies, the geisha and the prostitute as figures of sacrifice, which is not quite the same thing as submission. For, as the geisha

Mayumi remarks to Jodi Cobb, sacrifice can be a source of strength.

In premodern Japan, one of the ground rules of brothel and teahouse entertainment was that playing had to remain just that: playing. No matter how intently men sought to satisfy their romantic yearnings in the company of female entertainers, it was considered not only bad form but positively dangerous to mistake the elaborate forms of teahouse courtship for real emotions. For it was the underlying purpose of the licensed pleasure quarters, their raison d'être, to safeguard conventional family life by serving as an outlet for unrequited longings and desires. Real love between prostitute and client threatened the social order; men might forget their family responsibilities. But of course, men did sometimes fall in love with ladies of pleasure, and vice versa. And in reality, as well as in Kabuki plays, it was almost invariably the woman who ended by sacrificing her feelings, or even her life.

What is interesting, however, is that the women making such sacrifices in plays and films are not depicted as submissive or weak. On the contrary, it is the men in these affairs who are portrayed as weak, and almost childlike in their dependence on the women. This is partly because these stories were often meant to serve as morality plays, as warnings to men not to stray from the accepted norms of behavior. But the idea of the sacrificial woman as tough, maternal and independent, and the male as hopelessly feeble and irresolute, also reflects the mother-worship that is never far below the surface in Japan. It is still visible in modern Japanese films and novels, and in many of Cobb's photographs.

One of the most remarkable images in the book is the series of three photographs in which an older man attempts to pluck a cherry from the mouth of a handsome middle-aged geisha. She has tied the stem into a knot with her tongue and his efforts amount to stealing a kiss of sorts. It is a common little parlor game in Japan's "water trade." What gives the pictures their distinctive flavor is the facial expressions. They are hardly inscrutable: the woman is clearly in control. She teases her man, first avoiding his pursed lips, then finally granting him a peck on the mouth. His expression is far from being rakish or roguish, let alone macho; it is more like that of a child grateful for being allowed to play an adult game.

None of this is to say that Japanese males are never macho, or women never submissive. In public life, women have been oppressed for centuries. And until a few decades ago, becoming a female entertainer did entail real sacrifice, not only of a family life but of a private life altogether, even if it was sometimes true that, in Kurt Singer's words—in his book *Mirror, Sword and Jewel*—"[it] is in the style of their self-abandonment that [geisha] are granted a degree of self-determination denied to ordinary members of the human hive."

And yet, even that has changed. Nowadays it is Thais and Filipinas who abandon themselves to the Japanese pleasure trade in order to help brothers through school or to keep their families alive. Japanese women who become geisha, or hostesses, today—far more than was the case when Singer wrote about the fate of courtesans and geisha in the 1930s—do so out of free personal choice. They opt for the water trade because it frees them from other responsibilities. So far from being the simpering tools of men's desires, modern geisha have taken on a traditional form to strike out on their own, to become unassailable. There is dignity in that. And this is the quality that Jodi Cobb has captured in the pictures that follow.

# GEISHA

THE GEISHA DISTRICTS of Kyoto present a blank face to the world. Seamless rows of aged wooden façades, tiny two-story houses whose bamboo shades blind the windows, block any glimpse inside. The world of geisha does not give up its secrets easily.

Once, walls and moats denied entry to unknowns and exit to its captive women inhabitants, who were virtual prisoners, sexual slaves. Now, strangers may wander these streets, but without an introduction they would never dare enter the restaurants and teahouses where the geisha entertain. Geisha and *maiko* (apprentice geisha)—brief flashes of color glimpsed in doorways and limousines—do not acknowledge the existence of passersby. As dusk falls, serious black cars dispatch dark-suited gentlemen who disappear inside, slipping off their shoes at the doorway. Linen curtains shield the interiors from the curious. Nothing inside is visible from the street.

It is a formidable barrier for a photographer to penetrate. The geisha's impassive white mask reveals little emotion, whether of welcome or disdain. Her strict code of silence and fierce protectiveness toward clients conspire against revelation. The young girls in training are fearful of their elders, afraid of doing the wrong thing. The elders, steeped in their tradition of secrecy, have—one younger geisha told me—hidden things even from themselves. They have lost touch with their own feelings. They are armor-plated.

Enter Yuriko. She is the *okamisan* (proprietress) of a prosperous and popular geisha house that, with four *maiko*, two geisha and two twelve-year-old *tamago* ("eggs"—the youngest trainees), seemed more like a college dormitory than a residence of the demimonde. She would pull out her photograph album at any opportunity, her pudgy fingers caressing the pictures of past loves and proudly pointing to her younger, prettier, slimmer self on Hawaiian beaches and on boats in Sydney Harbour. Worldly and gregarious at forty-eight, vast of wit and heart, she was appalled by the image abroad of Japanese as stiff, serious, formal workaholics. Eager to show Japan's warm side, she opened her daily life to my camera.

Yuriko claimed a spiritual power to heal, and when she thought me in pain from carrying heavy camera equipment or spending too much time on my knees in the tiny rooms of geisha houses, she would cure me with neck and foot massages. I was not the only one she healed. People drifted in and out of her geisha house day and night. Clients, neighbors, friends, ex-geisha and *maiko* all came to be renewed by her energy and compassion.

And in Tokyo I met Mayumi. A dancer in one of Tokyo's most prestigious geisha districts, she is comfortable with foreigners, though weary of their misperceptions of her profession. She spoke only a few words of English, but with sign language and her own version of charades, she led me through the intricacies of geisha behavior. She taught me what gifts to give to whom, for one must never show up anywhere empty-handed. And when she thought I wasn't bowing low enough to some exalted person, she would reach over with her tiny, perfectly manicured hand and push my head all the way to the floor.

A fragile, flirtatious beauty at fifty-four, her soft cultured voice belied the strength of her convictions. Mayumi wanted the world to see the worth of these women whose lives had been hidden for so long. She pried open the door inch by inch, arranged introductions, persuaded reluctant geisha to participate, took me places I never thought I would see. When the conversations seemed the most stern, the most serious, when others seemed the most doubtful, and I would think all was lost, she would look at me and say, "Now take pictures!"

Through Yuriko and Mayumi, I came to my conviction of the nobility of the geisha.

I stopped briefly at other convictions: that they were tough businesswomen living off wealthy men, or hapless girls trapped into a life of subservience, or naughty women trading sexual favors for material gain; that they were coldblooded romantics, organized fakes, gorgeous fossils.

But as I discovered the women behind the masks, I came to know their truth. Until Japan's economic boom of the last twenty years, most women entered the geisha world through misfortune, not choice. At the heart of almost every

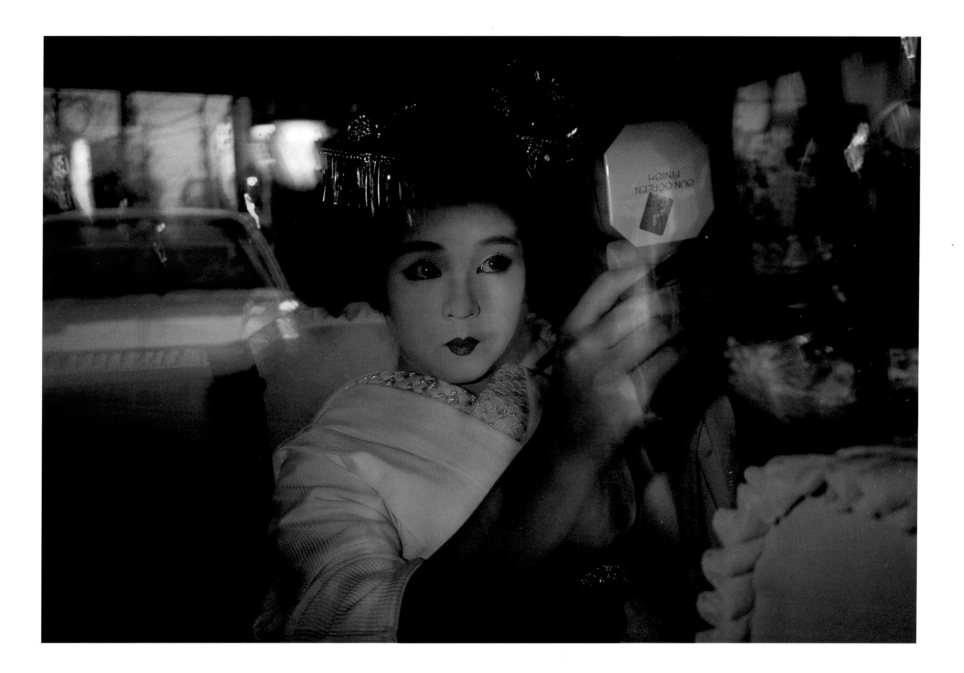

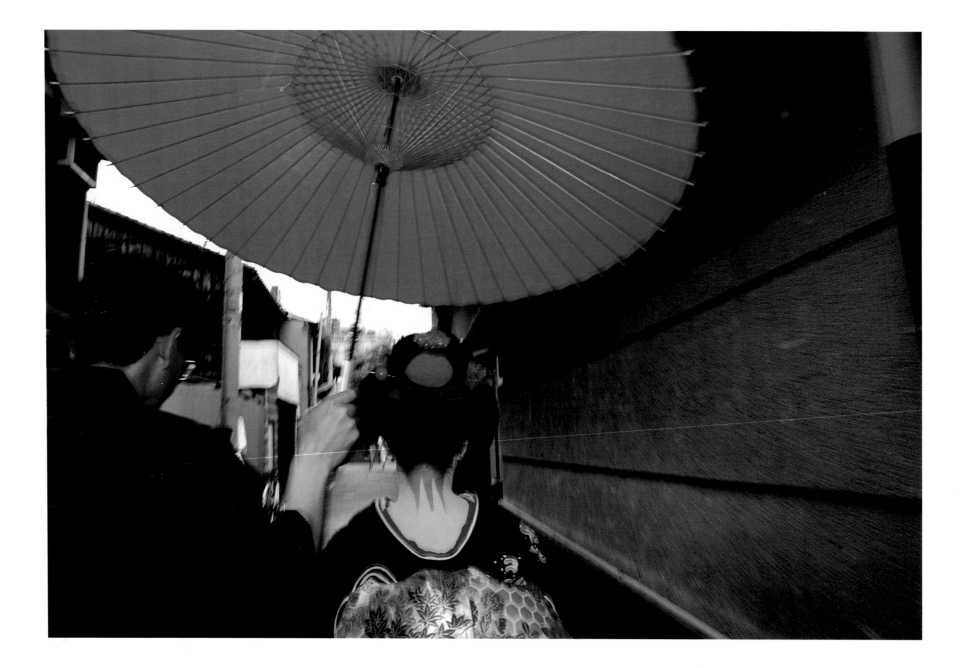

older geisha's story was adversity or even tragedy. These women had been sold by destitute parents, or abandoned by a husband, or born to a courtesan, a prostitute or another geisha. These were not bad girls out for a good time. They were good daughters, doing their family duty. Unable to change the larger culture, or their place in it, their triumph was to perfect that place.

Rising above her miserable origins, through discipline and talent the geisha created a life of beauty. She made herself into the image of the perfect woman, the embodiment of Japanese culture and refinement, a living work of art. That was the source of her pride, and of her salvation.

THE GEISHA TODAY is the aristocrat of the *mizu-shobai* ("water business")—the huge and varied industry that has evolved through the centuries to cater to men's sensual desires. But she is not a prostitute. If she provides sex, it is only at her discretion or as part of an enduring relationship. Her business is to sell a dream—of luxury, romance and exclusivity—to the wealthiest and most powerful men of Japan: top politicians, businessmen, and *yakuza* (gangsters). Behind the closed doors of the most exclusive restaurants and teahouses, political alliances are cemented and delicate business negotiations are conducted. Wives are never included. It is the geisha who pour the sake and keep the conversation flowing. The expense is enormous, even for Japan. And because the geisha's livelihood depends on her discretion, secrecy is the quintessence of the geisha's existence. Though her face is literally the symbol of Japan, most Japanese have never seen one, and often stop dead in their tracks when they do.

Geisha originated in the seventeenth century in the "pleasure quarters" of the cities of Edo (Tokyo), Osaka and Kyoto. These were areas separated from the rest of the city by walls and moats and licensed by the government for prostitution. Clustered within were the restaurants, teahouses, brothels, theaters and shops that served a vital role in the life of Japan's townspeople for hundreds of years, providing most of the culture the common man was ever likely to know. Here the men of Japan—feudal leaders and samurai (re-quired to check their swords at the door of the brothels); farmers; artisans; and the newly emerging merchant classes, despised by the nobility but often exceeding them in wealth—gathered at night to drink and converse, party and ostentatiously spend their money. And here flourished the "floating world" (*ukiyo*) celebrated in the woodblock prints of the period; here were the professional women who supplied musical entertainment, witty conversation and sexual favors ranging from the lavish and refined to the cheap and sordid.

Like the rest of Japanese society, the floating world was strictly organized by rank. The peasants were the *hashi* (bathhouse prostitutes); the nobility were *tayu* (high-ranking courtesans), skilled in poetry, literature and music, famous for their erotic skills and the gaudy opulence of their costume and bedding. In between were the *koshi*, displayed behind wooden lattices like gorgeously plumed but caged zoo animals, awaiting their selection by passing men. Geisha first appeared in this world as entertainers, dancing and making music to fan the fires of the courtesans' romantic encounters. The first geisha were males. But as women took over their role in the eighteenth century, the rules of the floating world forbade them to compete with a courtesan for her customers. Often, however, they refused to be bound by the rules, and their role has been ambiguous ever since.

Within the walls of the pleasure quarters, an intricate charade was played out. Dressed in layers of lavish silk kimonos, aspiring to perfection in makeup and courtly manners, women provided the illusion of seduction and romance in a culture that had little opportunity for the real thing. They would flatter and flirt, love and adore, and make the client the center of their universe, for the moment, for a price. The men acted the part of noblemen, gallant lovers, dandies and refined connoisseurs. Both pretended that the women were not low-born and often involuntary inhabitants of that world, and that the men were not paying dearly for their attentions. The fantasy of playing with women above their station appealed to the men, who were denied this pleasure in

reality. Pretense, moreover, had become second nature in general for the Japanese, who had lived for so long under an oppressive feudal authority that demanded total obedience. They were used to hiding their true emotions behind a façade of compliance.

FOR CENTURIES, Japanese society has been rigidly hierarchical. Japanese know precisely where they belong in their world, and precisely how to behave in their given role. The obligation of the individual to the group is the basis of the social structure. It is a strictly internalized discipline, and it is unquestioned. Private emotions, which can threaten communal goals, belong to the personal realm and must be masked. This gap between the social façade (*tatemae*) and true feelings (*honne*) is not hypocrisy, but a means of ensuring group stability. In any conflict between the two, the group ideally should always win.

Traditionally, men and women led virtually separate lives, their roles inflexible. Women were not educated, and stayed home caring for the next generation. Men dominated every area of life but the household. But, whether farmers or samurai, they were mostly prisoners of their class and occupation. Today that has changed, but not much. Work is serious in postwar, postindustrial Japan. A man is not trapped in his occupation but, rather, defined by it. His company provides his financial support, his friends and his status in the world. He works long hours, often late into the night, and socializes afterward with his colleagues. His first loyalty is to his employer, not his family.

Women, though now highly educated, are even today defined primarily by their roles as wives and mothers. Most are still at home, although some work in such low-paying, low-prestige jobs as OLs (office ladies), serving tea and looking decorative. They are expected to retire when they marry, and that is expected to happen by age twenty-five.

Until recently, marriage was not conceived of as the happy ending of two people's search for love. Marriage was a duty, an arrangement between two families to maintain social stability or political power. (Even today, one in four Japanese marriages is an arranged one.) Romance, that intersection of love and sex, has always been rare in this society, where casual contact between men and women, the play of the sexes, is not a part of daily life.

At the same time, the Japanese spirit is free of the guilt and restraint of Judeo-Christian beliefs that can make sensual pleasure dark and secretive. Buddhist, Confucian and Shinto traditions at the heart of what was for centuries a rural peasant culture all put sex at the center of the natural realm. Recreational sex with the legions of women offering it for pay has never been a sinful act, just a matter of what a man could afford.

This division between the worlds of family and pleasure is convenient for men who have contracted unromantic marriages. And perhaps romance without responsibility is really every man's dream. But throughout history, men have usually controlled the source of money. For women, whether courtesans, geisha or wives, economic survival has depended on their sexual availability.

Until the postwar years, women entered the floating world to survive. Japan was not only a rural country but a poor one, and *kuchi berashi* (reducing the number of mouths to feed) was a routine tragedy: parents regularly sold their daughters to the pleasure quarters, mostly to brothels, sacrificing some children so the others might eat. If the girls were exceptionally clever or beautiful, they would train to become either *tayu* or geisha. But they were still essentially slaves. They were bound by contracts to brothels or geisha houses, which forced them to pay for the fabulous wardrobes on which their reputations depended. Most ended up deeply in debt. Unless a customer bought them out of their bondage, they had nowhere else to go.

In this society, where a woman's place was either in the home or in the brothel, the geisha carved out a separate niche, creating a community of women that became known as the "flower and willow world" (*karyukai*). Despite the often harsh realities of this world, a geisha could gain an education of sorts, acquire an art, make her own money, establish an independent identity,

run a business, pursue romance and sometimes find true love. Although outside the bounds of orthodox society, it offered her refuge from social isolation and, ironically, more freedom than most other Japanese women had.

Though her world may be ambivalently perceived by the rest of Japanese society, today's geisha knows exactly where she stands on her own hierarchical ladder. Geisha districts (*hanamachi*) vary enormously in character, size, prestige and clientele. The top districts are in Tokyo and Kyoto, remnants of the pleasure quarters of old Japan. In Tokyo, geisha live an urban life, startling anachronisms in kimonos on busy city streets. They live alone in apartments scattered about the city, commuting to their *okiya* (geisha houses), which serve as offices and places to change clothes. Their clients, powerhouses of politics and business, never enter an *okiya*. With their geisha attending them, they hold the secret meetings that decide Japan's future in *ryotei*, costly private restaurants that are closing with alarming frequency as interest in the geisha world dwindles and Western culture overwhelms Tokyo.

Kyoto, Japan's heart of courtly life, learning, etiquette and religion since the eighth century, escaped the bombs of the last war. Pockets of custom and tradition, rapidly vanishing from the rest of Japan's landscape, survive there intact. Geisha and *maiko* live together much as they have for hundreds of years, and appeal to clients' nostalgia for a lost civilization. The tiny wooden geisha houses (*ochaya*) may enclose minuscule but exquisite Japanese gardens, and may contain a room where they entertain small groups. Their community of five small *hanamachi* is a closed and sometimes claustrophobic one. But the geisha are steeped in tradition and proud of their history.

At the bottom stand the *onsen* (hot springs) geisha, whose numbers vastly exceed those of the "true" geisha but who blur the line between pure entertainment and prostitution. At a hot springs resort, customers come in huge and often corporate groups, and the parties quickly disintegrate into rowdy bacchanals. The "true" geisha have nothing but disdain for *onsen* geisha: their training is not long or intensive enough, their heart is in the commerce and not the art, they are the geisha equivalent of a one-night stand. The *onsen* geisha respond that the "true" geisha have become too hidebound: they are too traditional, they have caused the decline of the geisha by taking all the fun out of it, they have almost priced themselves out of the market.

Though bound by rules and traditions that seem stifling to a modern Japanese woman, the geisha in her heyday was the pace-setter of fashion, popular culture and the arts. Celebrated in woodblock prints and romantic novels, gossiped about in the popular press, geisha started the trends that swept Japan: the way of wrapping a kimono or tying an *obi* (the sash around the waist), of styling hair, of conversation. They were chic and avant-garde, the supermodels of their time, emulated by proper matrons all over Japan. But as Japanese culture began flowing West, they froze in time, clutching tradition as their appeal. Their numbers began the slide that has now put them on the brink of extinction.

A century ago Japan had eighty thousand geisha. The exact number today is impossible to determine, but about twenty-five thousand are registered with various geisha associations. The overwhelming majority of these, however, are *onsen* geisha. The number of "true," top-class, traditional geisha in Tokyo and Kyoto combined stands at a perilous one thousand or so, and appears to be falling fast.

THE FLOWER and willow world is one of ritual, of ceremonial rites of passage, of formal bonds between geisha.

In Kyoto they live together in adopted family roles of mother, auntie, elder and younger sisters. There are no men in this family picture. The *okamisan* is the surrogate mother, and her authority is total. The few girls who enter the geisha world every year now come of their own free will at any age, drawn by the romantic image of geisha or a love of traditional arts. There is no more buying and selling. A parent negotiates a contract with the *okamisan* to provide the daughter with training and further education, to be paid for out of future earnings.

Visitor this evening
*We run up the long corridor*
Clicking of clogs.

Only one man,
Only one person to be loved.

I go back to my room,
*Retreat, honor,*
*Lacquered pillow,*
*Silence.*

I hear the watchman's rattle,
*Laughter in the next room.*

— GEISHA SONG

Before the war, a young girl sold to a geisha house knew nothing of art or culture. She was often just an illiterate country girl as young as eight or nine, needing intense training in social and artistic skills. Known as an "egg," she performed household chores—laundry, cooking, serving meals, helping the older geisha with their makeup and kimono—while absorbing the fine points of geisha life by close observation. By sixteen she had become a *maiko.* Today *maiko* still exist, but only just, and only in Kyoto, where tradition reigns. A *maiko* will go to parties, but is not expected to know the nuances of entertainment. She is a decoration and a diversion. Her chatter is often silly and childlike, her mistakes are frequent. But she is embraced. She is a new face, now so rare.

When a *maiko* enters a party, there is a gasp, no matter how jaded the company. She is preposterously cute. The chalk-white makeup, crimson bee-stung lips, long swaying *obi* and swinging sleeves give her a goofy but irresistible appeal. Her hairstyle—waxed rolling hills and valleys with ornaments sprouting like wildflowers in a field—will leave a small bald spot on her crown after a few years; it has been called the *maiko's* medal of honor, for the suffering she has endured. Tripping along on high wooden shoes, *pokketa, pokketa* down the street, caught off-guard at a newsstand reading comic books and eating an ice cream cone, she is really just a teenager on a glorious spree.

At about twenty she will become a full-fledged geisha. She is now more gracious, more at ease with men. As she ages, her kimonos become more subtle and softer in shade and color, her makeup more discreet, her hair a sedate bun at the nape of her neck, with an artificial puff at the crown to hide her bald spot. The full white makeup and wig are reserved for formal parties and stage performances. Her beauty, rather than the extravagant artificiality of the *maiko,* becomes an elegance based on her harmony with the season and the occasion. But she is never mistaken for an ordinary woman in kimono: her collar, draped rakishly low on her back, exposes more of the nape of her neck; her *obi* sits lower on her hips; traces of underkimono flash at collar, sleeve and hem. It is a subtle distinction, and a sexy one.

She has studied dance until the movements are second nature, the *shamisen* (a three-stringed musical instrument) has become an extension of herself. Her training in drums, *kouta* (geisha songs), tea ceremony and calligraphy will continue throughout her life—she will never achieve the perfection she seeks. But for all her artistic accomplishments, it is her skill in conversation that Japanese men claim to appreciate the most. She has become fluent in the news of the day, the gossip of the theater or sumo world, the naughty jokes making the rounds, and flattery both refined and outrageous. She has studied the male ego and tends it like a garden. She knows a man's moods and his seasons. She fusses, and he blooms.

She entertains nightly at one or two *zashiki* (a party and the room in which it is held) with only two days' holiday every month. She has many clients, but her hope is to win a wealthy patron to support and promote her training in the arts, provide her with lavish kimonos, trips abroad, a place to live and perhaps her own business. (Some geisha never find a patron.) She may have a child with him, which he may support and acknowledge. Most geisha outlive their patrons, for such men are usually elderly. But if she has the luck and the desire, and he is single or widowed, they may even marry, and she will then leave the geisha world.

Most, however, remain. The average age of a geisha is now over forty, and there is always a place within their world for the older women. Some are terrifying old crones, dour and severe, always scolding the younger girls, telling them that things are so easy now, not like when they were young. But most are gracious and professional, always alert to detect and fix whatever is wrong—a full ashtray, a stray hair on a *maiko,* an empty sake cup, a rocky love affair. They may run a geisha house, a club, a bar, a posh restaurant where geisha entertain, or a humble noodle shop where they gather for a quick bite and gossip; they may become teachers of dance and music. Some still perform in their district's yearly

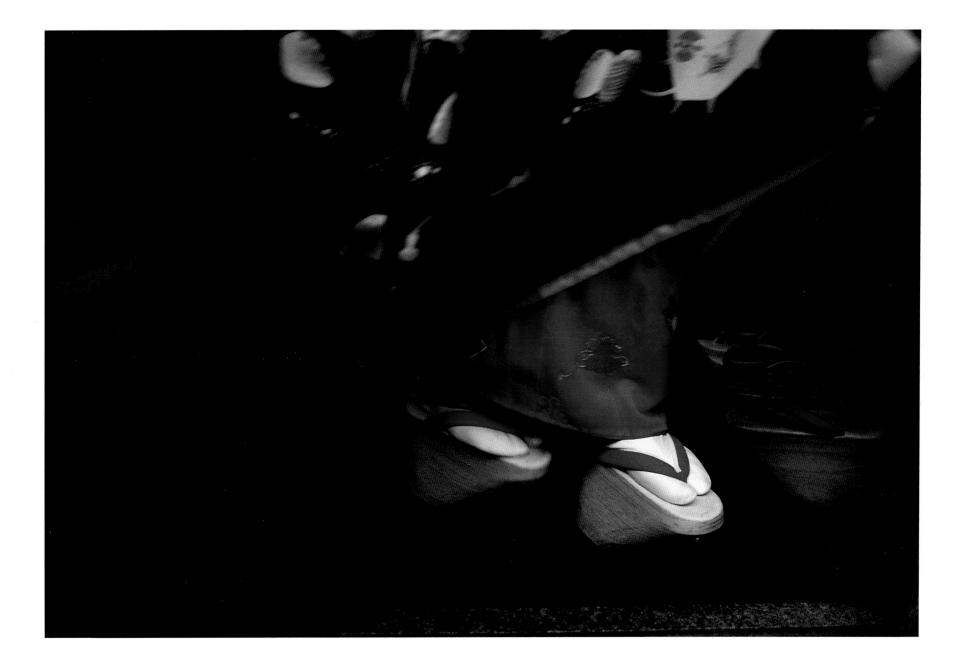

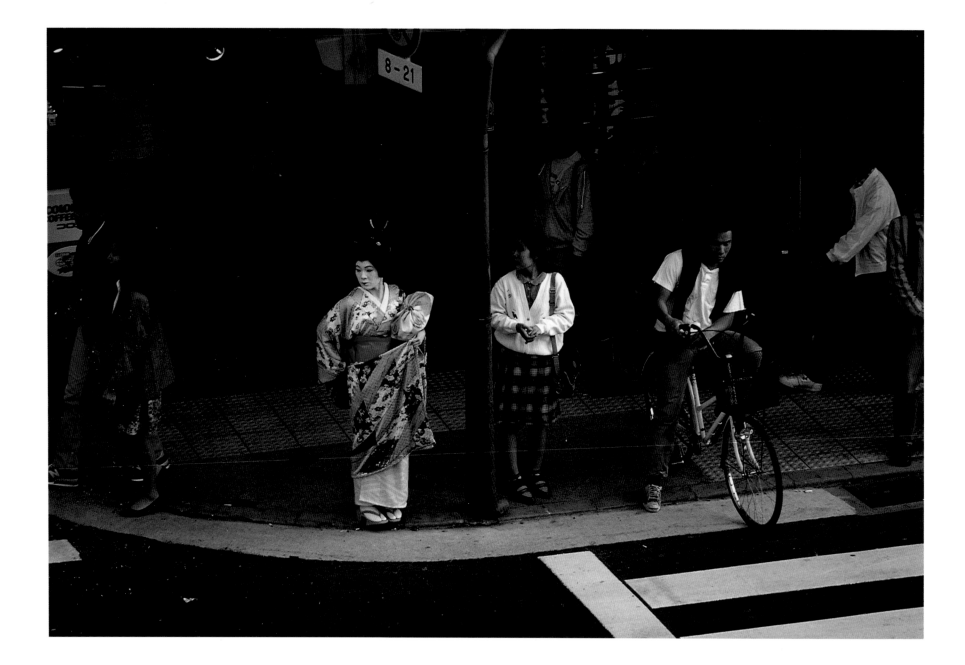

dances, even at eighty years of age, perspiring under heavy wigs and costumes in the hot lights, tiny and wrinkled and fragile up close but, in a triumph of discipline, dominant personalities on the stage.

THE GEISHA WORLD is sensual. It is the world of silk on soft skin, the aroma of fresh *tatami* and warm sake; it is the sumptuous banquets of tiny morsels and rare delicacies from the forest and the sea. It is the mournful plucking of *shamisen* and the hypnotic rhythm of drums. No jarring note, no waiter hovering to take an order or a tip, no ugly bill at the end of the evening to sour the illusion. The geisha's job is to provide a seamless flow of pleasure.

Her face, smoothed to eggshell whiteness, becomes a blank screen onto which desires and fantasies may be projected. She is beautiful but anonymous. All traces of her uniqueness have been erased. Her eyes and mouth are highlighted and emboldened, beacons to the opposite sex. The fashion for pale makeup swept the Asian aristocracy after a traveler to Europe in the Middle Ages returned with tales of beautiful women with skin as white as snow. Adopted by peasant girls in early Japanese brothels to mimic these noblewomen, the makeup seems at first a pathetic exaggeration, ghastly by daylight. But the light of a single candle reveals its enigmatic appeal. It glows golden. It blushes mysteriously. It is incandescent and alluring. In years past it was also lead-based, causing the premature death of many young geisha. Now its treachery is more subtle. First erasing age, boasting of youth, it soon betrays her, magnifying every bump and crease, concealing nothing but her individuality.

The geisha's place is secure in the Japanese aesthetic conviction, where the art is in the artifice, the distance from reality. Art is the gift-wrap that is as important as the present inside. It lies in making a ceremony of a mundane occurrence, a ritual of the ordinary. And it is the control of an artist over his material, whether a painter and his paper, a gardener and his bonsai tree, a woman and her beauty, a client and his geisha (or vice versa).

THE GEI OF GEISHA means "art," and a *geisha* is a "person who lives by art." But hers is not the art of self-expression; it is of the subjugation of self. Just as the Japanese measure the worth of individuals by how closely they conform to group expectations, so they measure art by how closely it conforms to a set pattern, an ideal. A geisha doesn't strive for originality, but for perfection. She doesn't create her art. It creates her.

Day after day, she trains under the watchful eye of a master—ninety-year-old Yachio Inoue, for one. Still conducting her own school of dance at the Gion Theater in Kyoto, she has been designated by the government a national living treasure and is revered almost as a deity. At sight of her, geisha freeze into silence, drop to their knees and bow to the floor. Armed with a stopwatch and a scowl, the master scrutinizes every tiny detail, from the expression in her students' eyes to the bend of their knees. Whispered critiques are rendered, imperceptible mistakes corrected. Hands and voices tremble. It is intensely personal training requiring absolute submission of disciple to teacher. The atmosphere is fearful and respectful. Criticism is often the music the geisha dances to. No mirrors line the studio. The master is the mirror.

The yearly dance performances are the only public display of a geisha's talent, and her moment to establish her credentials as an artist. Each district mounts its own production: the largest, Gion's Miyako Odori, has four performances daily for a month, the smallest lasts two days. Geisha prepare all year for these extravaganzas, but make no money from them. The cost is enormous. Artisans create elaborate costumes and scenery, wrap kimonos, style wigs, apply makeup, move the sets. All must be paid well and then tipped mightily by each geisha, whose backstage reputation rests on her largesse. Traditional Japan is labor-intensive, and comes at a breathtaking price.

Backstage is at once chaos and ritual. Geisha and *maiko*, in giddily colored costumes, flow on- and offstage like schools of tropical fish. Friends, clients and relatives bow and flatter, gossip and

"A geisha's virtue, her strength and beauty, come from history and tradition. She understands how the Japanese should be. She will teach you and lead you, yet make you look back. She is a hometown of the mind."
—Client

criticize. Everyone is pressing a shopping bag on someone else. It is filled with gifts of sweet or salty treats, scarves, fans or autographed handkerchiefs. Gaily decorated envelopes stuffed with large bank notes swiftly change hands. White-uniformed boys deliver feasts sent by admirers, the labels discreetly boasting of the prestige of the restaurants. Superb and rare flowers spill from dressing rooms into hallways. The geisha misses nothing. The importance of every visitor, the cost of every gift, is noted and remembered. The geisha's dressing area becomes her shop window, testifying to her popularity and prestige, upstaging her competitors—or not.

Onstage, the dance progresses in stately fashion. Movements are a series of restrained and elegant poses similar to Kabuki, accompanied by *shamisen*, flutes and drums, and rather funereal singing. Behind its appeal is melancholy, and the geisha is the paradigm of the Japanese Buddhist belief that beauty is rooted in the evanescence of life, and therefore its sadness. Despite her reputation as a good-time girl, what could be more tragic than a geisha whose beauty is as fleeting as her youth, whose life begins and ends in sorrow? So her dances are tableaux of love gone awry, unrequited passion, suicidal lovers, ghosts and destructive forces loose in the world. Slow, stilted, mournful, the performances display little exuberance.

But the art on display at the *zashiki* is another story. Some *zashiki* begin and end in perfect formality, a business or social obligation sedately discharged. But others follow a rowdier routine. The guests enter reverentially. After formal bows all around, the host seats the guest of honor in the position of respect, his back to the alcove displaying a painted scroll of consummate brushwork or a masterly flower arrangement. He is the picture of refinement. All is calm, all is exquisite, as little delicacies are whisked in and set before the guests. Geisha position themselves at the elbows of the customers, murmuring, smiling, urging little nibbles on them, pouring sake. A geisha executes a flawless dance, and the guests politely acknowledge its perfection. Then the alcohol kicks in. Faces redden, ties and tongues loosen.

The geisha begin their routine of party tricks, drinking games of "rock, scissors, paper" and chug-a-lug, and one shows her skill in tying the stem of a cherry into a knot with her tongue. A guest plucks the cherry from her lips with his own, and giggles at his impertinence. An argument breaks out over what people in Mongolia use for toilet paper. A geisha stands and demonstrates.

The elderly geisha in the corner strums her *shamisen* and warbles ribald ditties until a band arrives, and a microphone is passed around to the guests so they can share their musical talents. No one listens. One man collapses to the floor and takes this moment to nap. Another grabs a geisha and begins ballroom dancing, scrunching her *obi* and tripping on the hem of her priceless kimono. No one minds. If the men are young and the mood hits, they may play strip games. But the geisha never loses. She is still removing hairpins as he wriggles from his skivvies. At a hot springs party, two men in cotton summer kimonos dance cheek to cheek. Two others, their napkins wrapped around their heads like samurai headbands, pull down a man's underwear as he waltzes with a geisha. No one notices. Still the sake keeps arriving, and the beer, and the whiskey. (Mornings in a geisha district are mounds of empty bottles waiting by doorways for the garbagemen.) The gentlemen revel. Then, suddenly, it is over. As if on cue, the men lurch to their feet, and the geisha rearrange their dignity. Shrieks of Okini, okini! (Thank you, thank you!) follow the men as they make their unsteady departure. The geisha escort them to the street, pour them into their limousines or taxis, bow and squeal and wave goodnight. And make their own way home. A geisha tucks herself in and writes in her diary.

The bill arrives by mail some days later. It may top ten thousand dollars for five guests.

WHAT DRAWS a man to this world? A *zashiki* is his refuge from unrelenting pressures to conform. Behind a mask of alcohol, he can loosen society's death-grip on his psyche, play and laugh and say what's really on his mind, be babied and

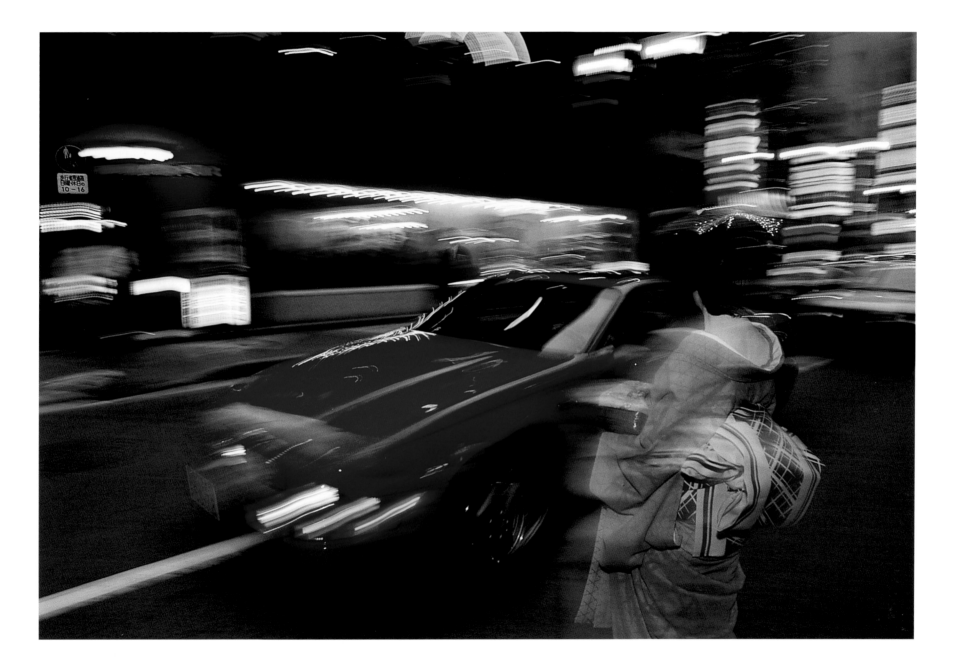

coddled and cuddled and adored. The geisha is his co-conspirator and confidant. Nothing that goes on here can be held against him. After his nightly or weekly or monthly catharsis, tomorrow is a blank slate.

Ideally, a geisha is a man's ultimate luxury item, the symbol of conspicuous consumption. But he in turn brings something to the geisha world. It isn't just that he has lots of money; he knows how to spend it. To have a mistress of undisputed class and consummate artistic achievement, to keep her in sumptuous kimono and elegant surroundings, to know how to converse with her and please her, to be iki (chic), to be welcomed in the most exclusive clubs, is the mark of a successful man. He knows the subtleties of her dance and the words to her songs. He defines himself by his connoisseurship, just as a geisha defines herself by her art.

Like the geisha's, his is an inherited tradition. He may be just as trapped as she by the sometimes suffocating rigidity of Japanese society. All of Japan's citizens have their appointed roles, and all seek ways to bear up under them. The geisha struggles for perfection, her client for release.

But Japan is changing fast. Geisha districts, once oases of culture in a gray world, are becoming islands of irrelevance in the backwaters of relentless urban life. Japanese life has more of everything: more art, culture, pachinko parlors, televisions, magazines, movies, shopping, travel. "Soaplands" (bathhouses providing an extensive menu of esoteric sexual services), love hotels and massage parlors abound in every village and town. Millions of pornographic comic books are sold weekly at neighborhood 7-Elevens and in street-corner vending machines. A kaleidoscope of bars and clubs offers hostesses and prostitutes eager to cater to the harassed, overworked salaryman. Sex is now a blatant commercial industry.

In modern Japan, men flaunt their wealth by joining exclusive golf clubs and driving fast cars. Traditional arts are becoming inaccessible, Western culture pervasive. Prosperity has ended the need for the Japanese to put their children to work, whether in the fields or in the brothels. Women are gaining grudging respect. More young people are choosing careers and mates for themselves, and notions of romance are creeping into their dreams.

Everything about the geisha, her kimono, her makeup, her art, her very existence, is bound to history. Samurai and merchants, wartime generals and men of the imperial household knew her, knew the same face she now presents, her same bawdy songs and silly games, and many knew her favors as well. In her presence deals were made, plots were hatched, wars were planned. But she never told. In her silence and secrecy, her obsession with perfection and her disciplined devotion to the arts, she became Japan's unparalleled guardian and conservator of tradition.

In the rush to embrace Western culture, the exquisiteness of old traditions is being lost. The love and attention dedicated to the detail of things, whether the placement of the fan in the tea ceremony, the intricate pattern of an obi, or the arch of a geisha's eyebrow, are giving way to the lust for material goods and instant gratification. The notion that an entire life can be dedicated to beauty is fast vanishing. Only a dwindling number of aging men can appreciate, or afford, what a geisha is so rigorously trained to do. This may be the last generation of true geisha.

## MAYUMI, TOKYO GEISHA

FROM THE MOMENT I was in my mother's belly my future was predestined—I was on the geisha conveyor belt. My mother's parents had sent her to Tokyo to the geisha trade when she was eight years old. It was a common practice then—kuchi berashi [reducing the number of mouths]—there were just too many children in their family to feed. She never questioned it. She was adopted into my grandmother's family to inherit her geisha house. I am a child of this household, even though my grandmother is not my blood grandmother. Blood relatives are not important. My family is my geisha family.

I was a child "born of a single leg spread" [hito matagi no ko]. My father had many other women

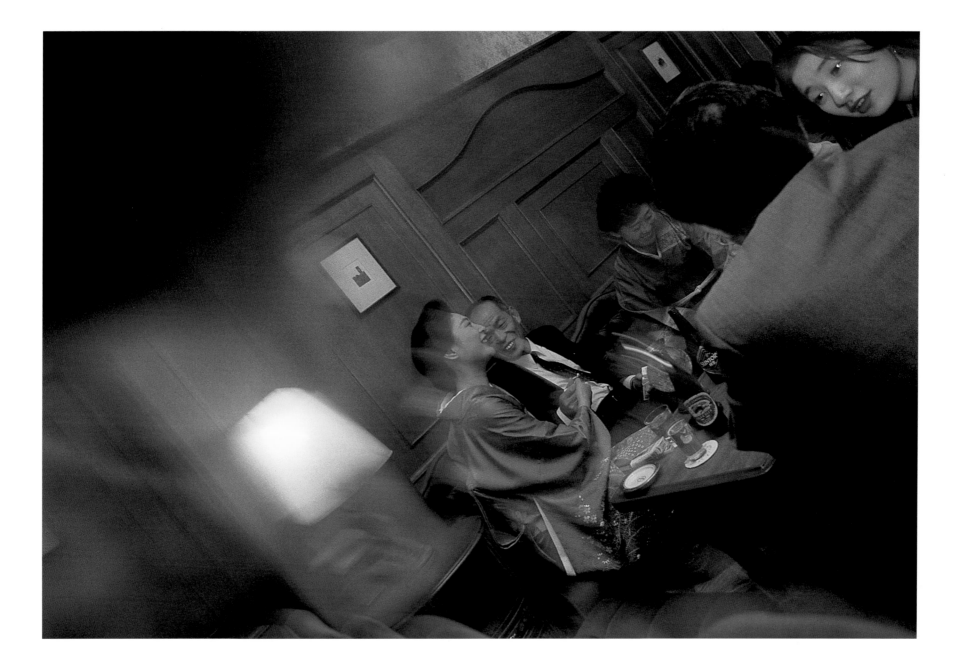

besides his wife, some geisha and some "amateurs." Mother had spent only one night with him. She didn't love him; she just sold herself for the evening to pay off my grandmother's stock-market debt. When Mother told my father she was pregnant, he refused responsibility, saying "It's not my child." Mother said, "Well, I don't need your money; a child is a precious thing and not a matter of money." He never supported me, but later introduced me to his legitimate sons, fearful that if we ever met by chance we might fall in love. He wanted to avoid any chance of incest.

There was no question of my going to school or following a normal track, and no wondering what might have been. The geisha world was just the air I breathed. I began my training in the traditional way, on the sixth day of the sixth month of my sixth year. And I acquired my first patron in the traditional way. He met me at a *zashiki* and came and got me. It has always been that way in the geisha world. Men simply approach a woman, and if she doesn't want him she's free to reject him. But I liked him. He said he'd like to be my patron, and the arrangement was made through the *okamisan*. That's all there was to it. It was more business than romance.

He visited me about twice a month, and in between I could do as I liked. If he had been the jealous type, he would have bought a little house and put me in it and kept a close eye, but he wasn't. He also could have had others like me in different geisha districts and I might not have known. It would depend on his wealth. There were men who had geishas in each district, and sometimes they all knew about each other. I knew a patron who had ten women strung about—it was quite a struggle that went on. A competition would spring up among all the women attached to the one man, and it was actually a good thing for the geisha world. Ideally, the jealousies would focus on one's own skills. If one of his women had just done a wonderful dance, the others would be jealous and do even better. So it became a battle of skills rather than simple hatred. But there were also confrontations, slapping each other's faces in the *zashiki* and such.

Most women entered the geisha world young and penniless, and the search for a patron started as early as eleven. I've had several—many—but secret. I don't like the word *patron*, that implies selling my body, and my relationships weren't about that. I was fond of them all. Of course, I slept with the men I was fond of, but not to benefit financially from them. I didn't see it like that. I'm not a geisha in the sense of selling my wares. Maybe I inherited that from Mother. She supported herself running her geisha house; pride kept her from taking money from the men she loved. I've inherited that pride.

I met my first love more than thirty years ago. I was so smitten I visited him every weekend. I had a patron, but I told him I loved someone else. I stopped working the *zashiki*, and in my world if you do that you can't eat. Mother said to me, "Wake up. You're not going to be able to get by financially. He's got no money, your profession is at stake, and you're ruining it by carrying on like this. This whole thing is absurd. You can always find another man, but you can't find another mother. Wake up." She wasn't asking me to choose between him and her. She wanted me to throw him away because it wasn't going to work. My first duty is to Mother, to make my life as successful as possible for her. This is the Japanese way. She gave me the insight I needed to say goodbye to him.

Still, I had desires to marry, and a Kabuki actor and the son of a restaurant owner proposed to me. But Mother turned down both of them, saying I was better off as a geisha. In truth, I was doing what I wanted to do. I was sought after and successful, and my life was full of people flocking around. I could see my friends out there washing dishes and looking after other people and just doing drudgery. I loved being a geisha.

Then, twenty years ago, I met my true love. It was one of those special relationships that fit. Physically, sexually—everything fit. When I was young I had all sorts of experiences and learned all the usual aspects of sex, but this was different. It didn't matter what we did to each other; anything was possible between us. We could have violent quarrels and even hit each other, but then

we would sleep together and everything would be absolutely perfect again. I was so lucky to have had this experience in my life. No one else will ever hold a candle to him.

When we first met, I found him dull. He had never had an affair before, and I set out to seduce him. I arranged an occasion where he would be staying at a friend's *ochaya* for the night, and I lay down with him. But before we could even begin, he came all over my kimono! [Mayumi laughs.] He said he had never felt this way before, and it was incredibly powerful for him. It completely went to my head.

Once it was on, it was on in a big way. He was much older than I, and lived in a different city from his wife and children because of his work. Every night, the moment I finished working my *zashiki*, I would rush to him and we would make love. Every night—up to six times! I had this way of sort of hanging on to him, which would bring him on. . . .

Every morning I would take my dance lessons, every evening I worked one or two *zashiki*, then I would go off for the night with him and come staggering back in the morning and start the next day. I was so young—I can't imagine doing it now, going without sleep like that night after night. This went on for two or three years. Mother was as mad as the devil! [Mayumi puts her fingers to her head like horns, also a symbol for jealousy.] I was deep in debt and not working as seriously as I should have.

We decided to marry. His wife had hired a detective to follow him, and she found out about me. She agreed to a divorce, and had already put her seal on the divorce papers, but I decided to wait until their children were grown. If their father had divorced to marry someone like me, their career and marriage possibilities would be in jeopardy. His responsibility was to his wife and children, and my responsibility was to see that he carried that out.

That was my gesture to his wife. I had already taken her husband away emotionally; his heart now belonged to me. That was the least I could do, if I was to be forgiven for the sin I had committed against her.

Then one night last year when we had a date, he didn't show up. He had been rushed to the hospital with a heart attack, and soon died.

My hope was that we would be like the old couples in the advertisements, going on holidays, spending our old age together. I was banking on a final happiness with him. I assumed that by putting it off a few years all would be fine. But now that won't happen, and it's tragic. He was the love of my life. I won't have anyone after this.

Mother was the only one who knew. Geisha don't often confide in each other; they are professional at hiding these things. As long as you're not out in the streets together, who's to know? Your private life is your private life, and your public life is your public life. They don't meet. Secrecy is the essential art of geisha.

On balance, I think my fifty-four years have been good years. When I was a child I resented my fate, the way I was conceived and the world I was born into. But now I'm grateful to Mother, and it's my relationship with her that I cherish the most. Now, given the choice between her and a man, I would choose Mother. I've made that choice before, and I'm satisfied that I've conducted my life as I should have. My greatest success was to not go into debt—I managed on my own. But I should have been born a boy. I would have been freer, without all the criticisms of my world. They stuck the wrong bits on down there! [Mayumi looks down at her lap and laughs.]

But it comes to this: Women must sacrifice themselves. If you are a woman, then you are the one who must be strong. You are the one who helps, the one who acts, the one who saves. All over the world, it's the same. Whether a geisha, or a wife, or a hostess, or a companion—women's strength comes from their role in the world. Self-sacrifice comes from the strength of a woman and creates the strength of a woman.

## YURIKO, GEISHA HOUSE
### *OKAMISAN*

I'M FROM KYUSHU, which is famous for male chauvinism. It is still absolutely feudal. Boy

children are welcome, girls are not. Rich men can have all the wives they want, and my father and grandfather were very wealthy. My father had seven wives, and I lived with fifteen brothers and sisters. They constantly tormented me, but I didn't know why. No one told me the truth. I was always told strange things, like "You are a child who was put in a box of oranges and brought from the river." I thought, "Why?" Finally my grandmother told me that the mother I lived with was not my real mother. I decided to leave and find my real mother. I was eleven years old.

When I found her, she had married a poor carpenter and had four other children. They couldn't afford to raise me. So they sold me to a hospital in the countryside, far from my home. My mother sold me! My real mother *sold me*. She lied to me. She told me I could go to school at night and become a nurse, but everything she said was a lie. I earned only a tiny amount of money at the hospital every month, and my parents got every bit of it in advance, so I couldn't leave. I was just a slave.

I had to do so much. With my own hands I washed bandages—sometimes filled with pus from patients' wounds—under a waterfall. The owner of the hospital also owned the rice shop, and I had to deliver rice to people's houses, cook it and care for the children, all while carrying someone else's baby on my back. I didn't even have enough money for underwear; I used rags to make my own. Twice a year someone gave me old clothes. I didn't have normal shoes, just rubber thongs. And I was always hungry. I was the last one to be fed, and there was never much left. A normal person couldn't have survived all this for even three days.

[Yuriko begins to cry softly.] Oh, I had such a hard time. For four years I worked from six in the morning until one in the morning. I did nothing but work, work, work. Finally I just didn't want to live anymore. I found some pills in the hospital and tried to kill myself. I almost died, and the vision I remember was white stairs with many clouds above them, and golden flowers all around. It felt wonderful. But when I tried to go up the stairs, I saw a white fog in front of me

and heard everyone calling "Yuriko! Yuriko!" and I realized I was alive. They had already put cotton in my nose and mouth, thinking I was dead.

I became an outcast because of my suicide attempt, and was sent to the Juvenile Welfare Commission. I learned some philosophy there. I learned there are three kinds of people in this world: people needed by society; people who are a bother to society; and people harmed by society, whom nobody wants. I was determined to be the first type, but I needed to support myself.

I went from place to place, to Hiroshima, Osaka and other cities, working in clubs and cabarets. I was under twenty, so I kept my age a secret and lied about my name, but after about three months I would always be found out. The police would come, not to arrest me but to protect me. So I would move on to another city. When I was seventeen I finally came to Kyoto, where I met an *okamisan* who convinced me I could earn money leading this life, and that I would learn the traditional arts as well. Most people think of this world as very severe, but for me, compared to the world I had known, this place was heaven.

At nineteen I had *mizu-age* [a *maiko*'s first sexual experience] with a client who was seventy-two years old, the president of a very famous kimono shop. I had no choice; at that time everyone had to have a patron. It was my duty, the only way I could pay off my debt to my geisha house. If I had refused him, I would have been banished. It now seems like a kind of sexual harassment, but in fact my patron was good for me because he was interesting and treated me well.

But after three years I had many clients and didn't need him any more, so I told him there was a man I truly loved and wanted to marry. He thanked me profusely for all I had done for him, and gave me quite a bit of money for my marriage. But of course I wasn't actually getting married. [Yuriko laughs.] When my lie was discovered, I left to start my own business, a small club. I was twenty-two.

Right away I fell in love with one of my clients. He was already married with children,

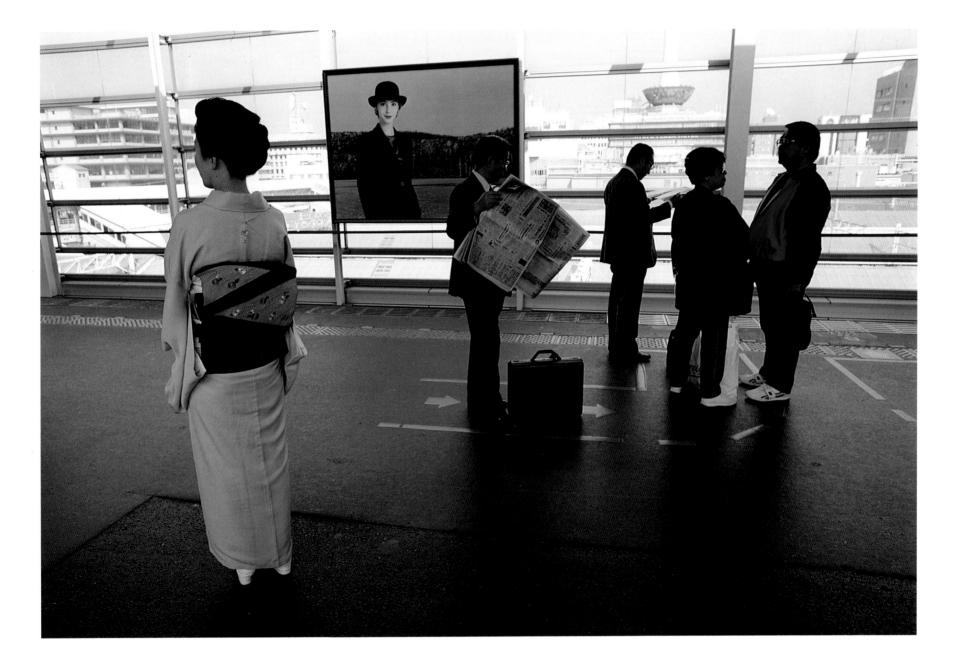

but came to see me every day. We couldn't leave each other alone—sometimes we were together twenty-four hours a day, just driving around or playing mah-jongg, and always drinking. I lost all desire to work, and we spent everything I had earned. But soon I began to worry. How could we support ourselves? What would happen to his children? So I broke off our relationship and came back to the geisha world to forget him.

At thirty I fell in love again, and had two children, but I just couldn't marry the man. He was always involved with other women and spent all my money. Once I even thought I would have to sell my house and my land. But eventually he left me and married someone else.

Then one night my first love walked back into my club. It had been fifteen years since we'd first met. He was still so handsome, and I still loved him. His wife and I then fought for five years—I would go to his house to take him, and his wife would come to my house to take him back. Years earlier I had sent him home to his family because of his responsibilities to them, but I had still been waiting and hoping. I just couldn't help it. And now his wife has given in. I can see him again, though not as much as we want—I'm too busy taking care of my business and children. Mostly he comes here on Sundays to see me, and we go to the shrine to pray.

I have had a hard life, and so many regrets. But I believe that there are souls in the world that are meant to be one's children, and I have given those souls life. And I found love. I believe in reincarnation, and I promised my lover that we will marry in our next life.

## YURIKO'S GEISHA HOUSE

MY MOTIVATION in life is to not become the kind of human being my real mother was. Even dogs and cats want to take care of their offspring, but my mother did nothing a real mother would do for her children. Many geisha and maiko have only one parent, and some have very serious family problems, like I did. So I bring girls into my house to raise them, and discover the talent in them. I try to take care of them as daughters.

A girl has to train for years to become a maiko. I must feed and house her, send her to school, buy her clothes and pay the fees for art training. A maiko must change her kimono every month, and also needs a formal one, so I have to buy at least thirty-five kimonos for her, each one unique, each costing as much as two million yen [twenty thousand dollars]. And tabi [split-toed socks for sandals] and hair accessories, and obi—these things are very expensive because each one is handmade by artisans.

It costs fifty million yen [half a million dollars] to raise one maiko, and they pay back only thirty million. So I lose money on them, but I don't care. I need them for the prestige they bring to my house. Clients will trust me more if I have many maiko—it is proof that I have enough money to raise them. And parents will know that I will take care of them. If your daughter said she wanted to be a maiko, could you send her to an ochaya that wouldn't assume responsibility for her?

Kyoto maiko should be virgins. They should never sell themselves, never sell their bodies. They are not prostitutes. That's why they look so pretty and a little bit childish. Once they start to know men, they can't concentrate on their art. But if they fall in love with a suitable man, I can send them from this house to marry.

I'm running this business out of gratitude to the master who taught me to dance—I want to maintain the traditional manners and arts she worked so hard to preserve. She was strict, but I respected her. When she was alive she said I never worked hard enough, but since she passed away I've worked even harder. She had become like a mother to me, and I inherited her family crest, which I wear on my kimono. I would like my own daughter to become a maiko and inherit this ochaya, but I can't force her. I had her start lessons in the traditional way, on the sixth day of the sixth month of her sixth year. But she doesn't like Japanese dance—she wants to play the piano. She is the first generation of geisha daughters to have her own will. [Her ten-year-old daughter chimes

in, "I want to be a cop," and the fourteen-year-old son shouts from his room his opinion of living in a geisha house: "I want to move to a country where there are no women."]

So I will choose one of my geisha or *maiko* to inherit my *ochaya*. Because we live together and spend a great deal of time with each other every day, I can tell their true character, whether they are loyal or self-centered. They should not speak ill of anyone, and should not have an opposition between their public and their private selves. They should not engage in *ura omote* [two-faced behavior], where in front of me they work very hard but behind my back they do nothing. They must be generous and thoughtful and have the mind of a mother; a sense of reality, independence and their own will; common sense; a philosophy about what is bad and what is good. Even when people around them are doing bad things, they must keep their own counsel.

I will choose someone like that to inherit my house. And then I want to buy land in the countryside and gather people together who have been abandoned by their families or society. I would heal them. That's what I would like to do for the rest of my life.

## KYOTO CLIENT

I AM ninety years old, and my marriage was arranged through an acquaintance of my uncle almost seventy years ago. He told me about a girl, and I said, "Okay, we'll get married." When I first met her I almost changed my mind, because I wanted to marry someone more beautiful. But she didn't have any other shortcomings, so I said, "Well, if you really want to marry me, then you can." If I married someone I really loved, I would have to be very obedient to her, and I didn't want to be controlled by my wife. I didn't fall in love with her—we didn't have such feelings back

then—I just thought that my wife would be able to maintain my life and my family.

I first started playing with geisha when I was twenty-four, but not for sex. I just enjoyed their company and liked to drink with them. I was very popular among the geisha—I was so much younger than their other guests. They were so beautiful! But when I became interested in traditional music, I came to appreciate them as performers. My wife knew that and trusted me. I always told her what happened outside of our life together, and she wasn't jealous.

I like to write and sing the songs myself, and have the geisha play the *shamisen* and dance. Japanese traditional music started with the *shamisen*, which was played inside a small room, in private. So it's a very personal relationship between the entertainer and the audience. Side by side, this close. My music expresses deep feelings about love between men and women, so I must use geisha for inspiration—they are more affectionate than normal people.

I think it sad that the number of geisha is decreasing so quickly. Bar hostesses are replacing them, and hostesses don't need the skills of a geisha or her expensive wardrobe. The young generation now only like *karaoke* bars and popular songs, so they're not interested in traditional music anymore. And the young girls don't want to go through the hardship of the training. So the existing geisha are aging and really, the clients don't like the older geisha very much.

In the olden days, if a man of a certain class wanted to play with girls, he had to go to geisha places—the bars and clubs that existed were beneath him socially. Geisha were status symbols. If a man of high social position or great business success got involved with a lower-ranking geisha, he would be shunned by his male friends. But if she were a high-ranking geisha, everyone would accept that he had a mistress. If his wife protested, she would be laughed out of society. But now, the power of women is getting stronger.

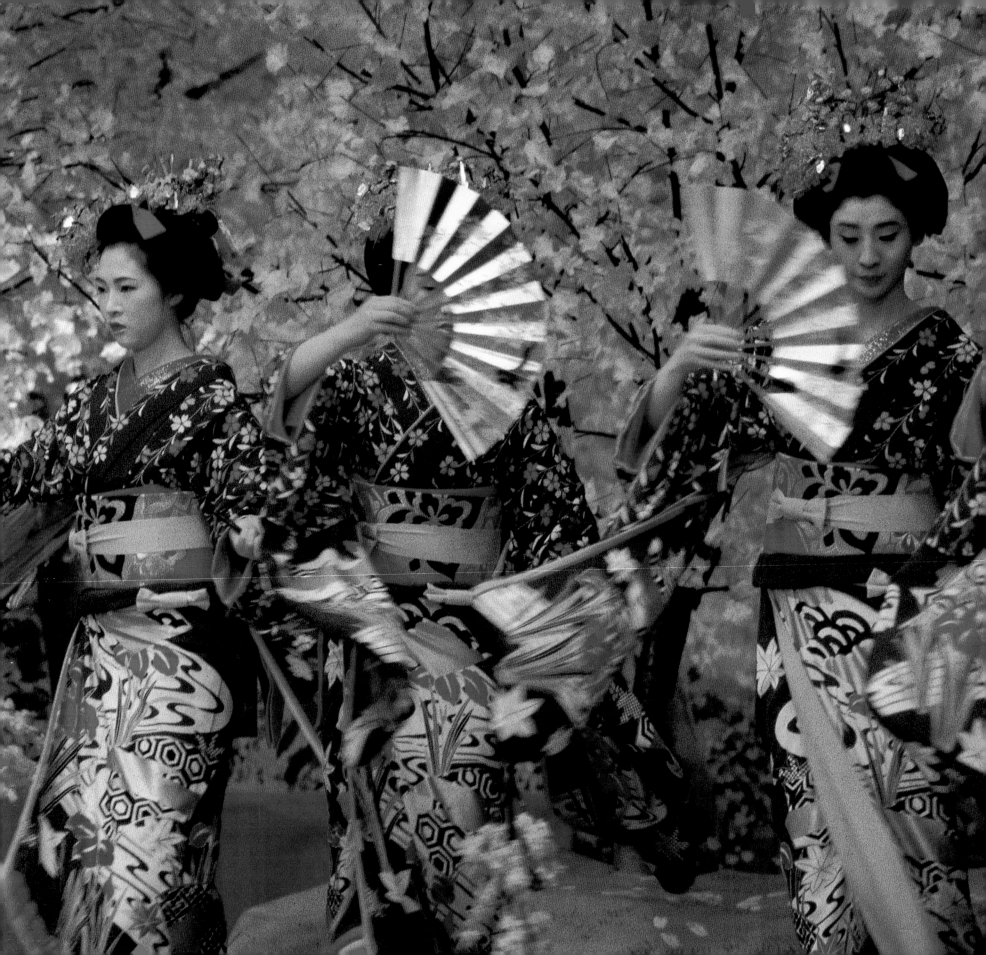

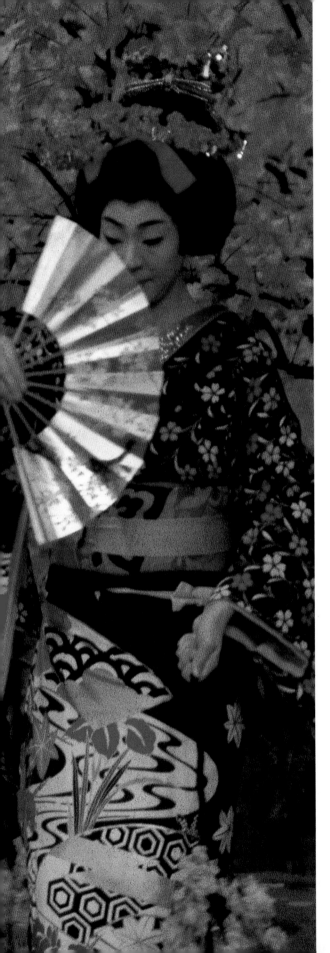

# A WORLD
# OF ART

"A geisha contains her art within herself, and because her body has this art, her life is saved. That is the power of art—the salvation of one's soul."

—Mayumi, geisha

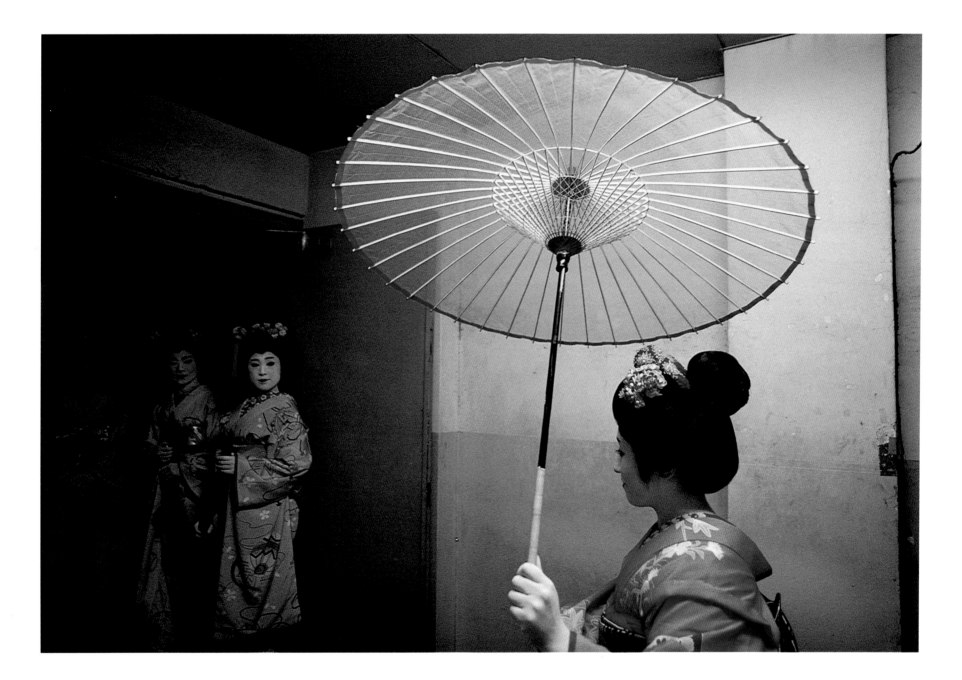

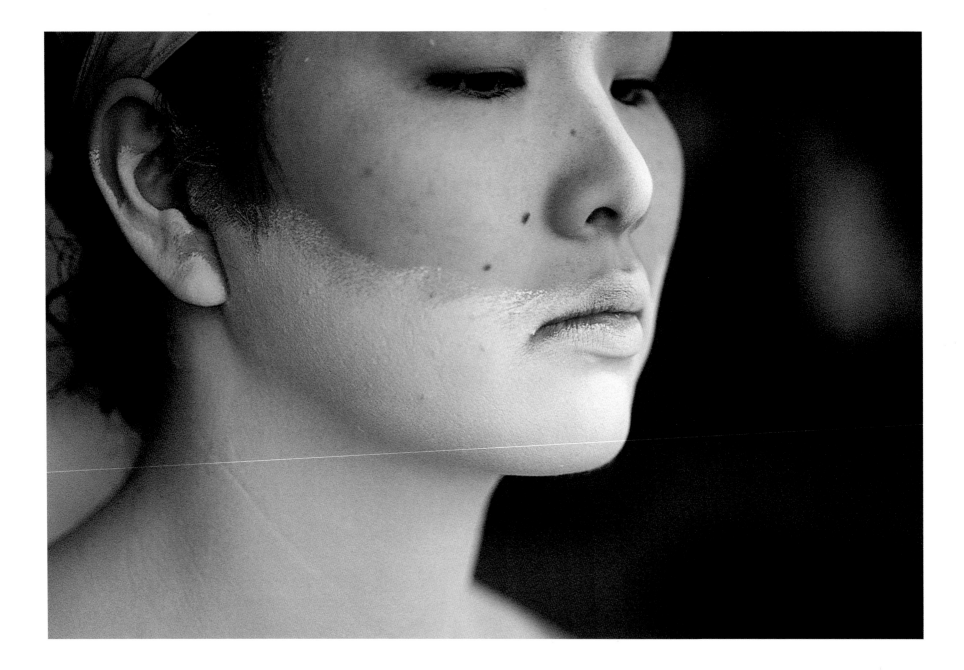

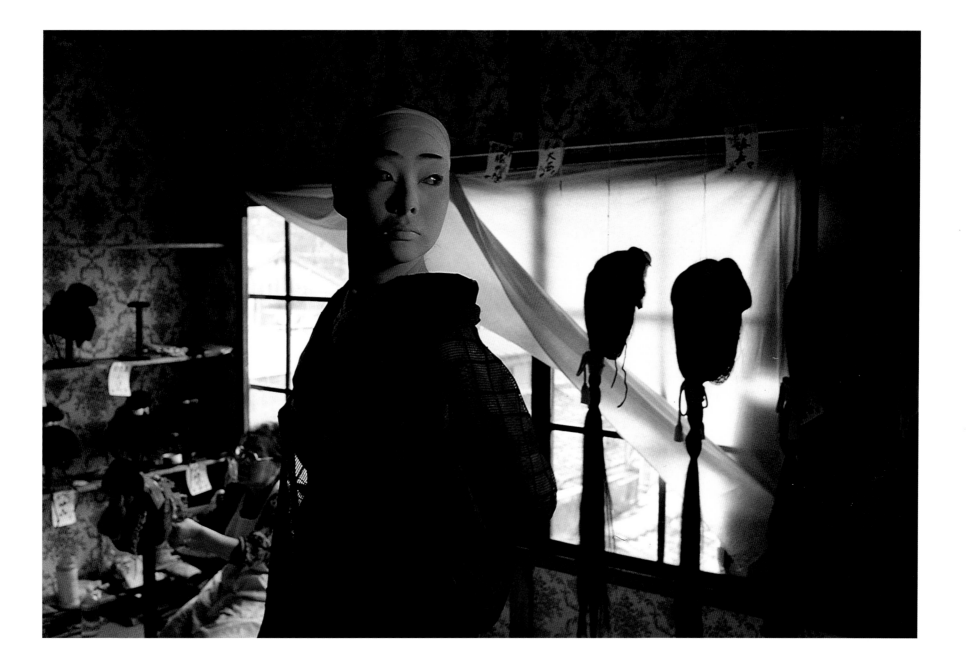

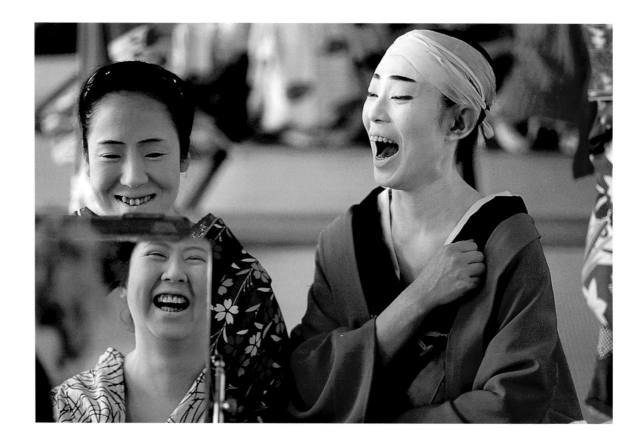

"Last night I had a client from the Meiji era [someone past eighty] who tried to touch my body! It was horrible! I tried
  to escape!"

"My date slipped down the stairs, fell flat on his face, and looked like he'd been flattened by a tractor. I now call him
  Tractor Uncle!"

<div align="right">—Backstage chatter</div>

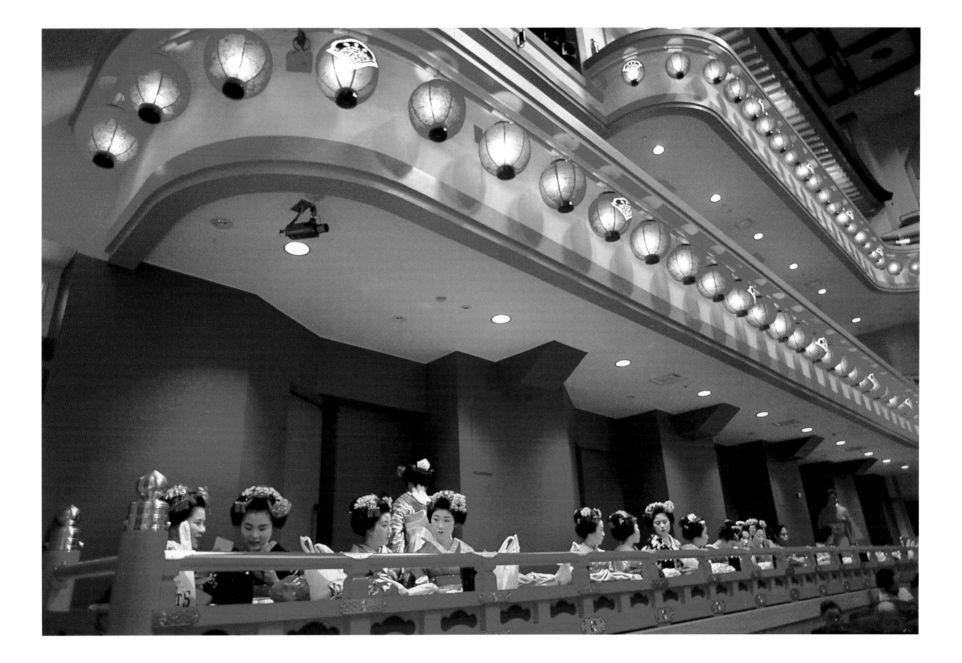

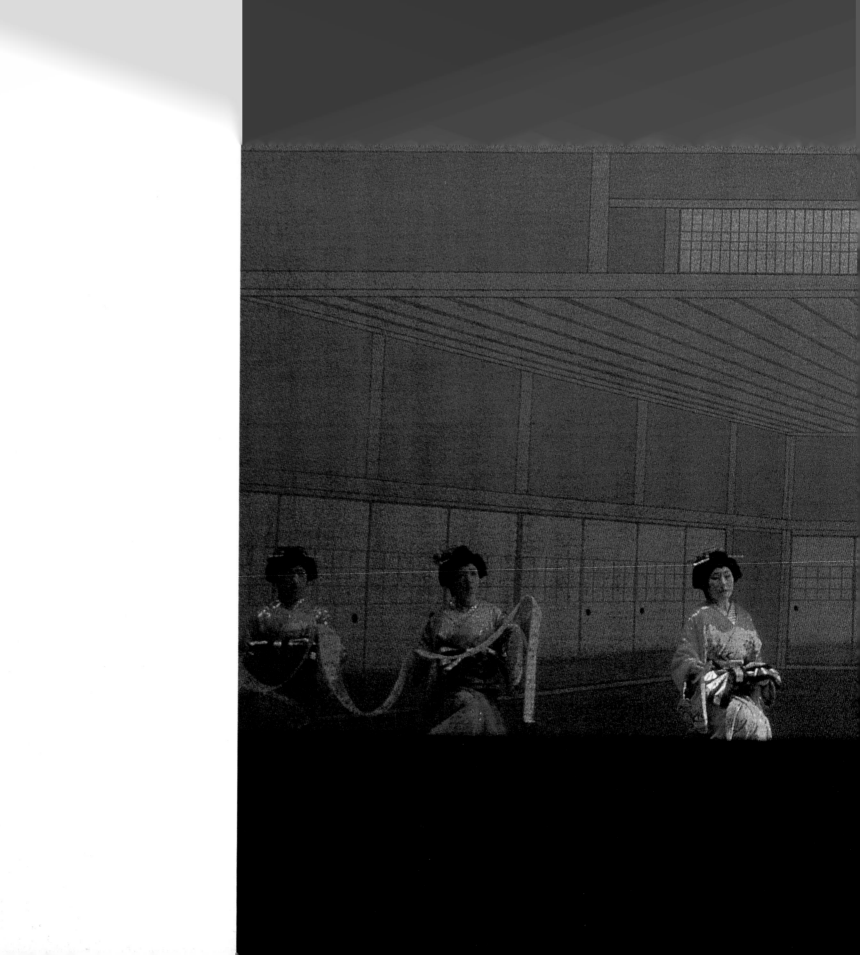

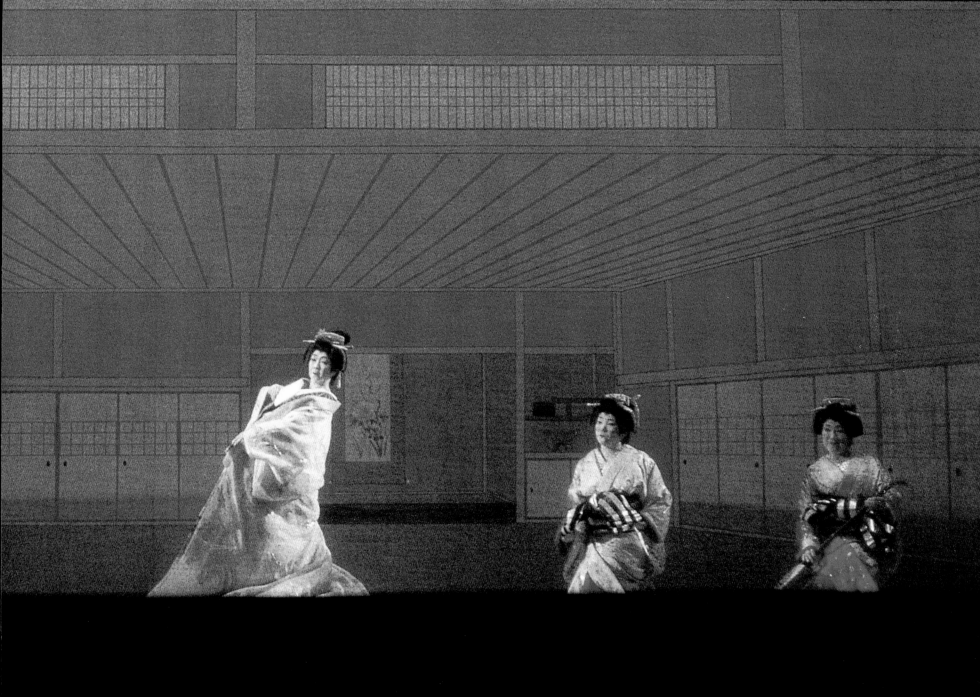

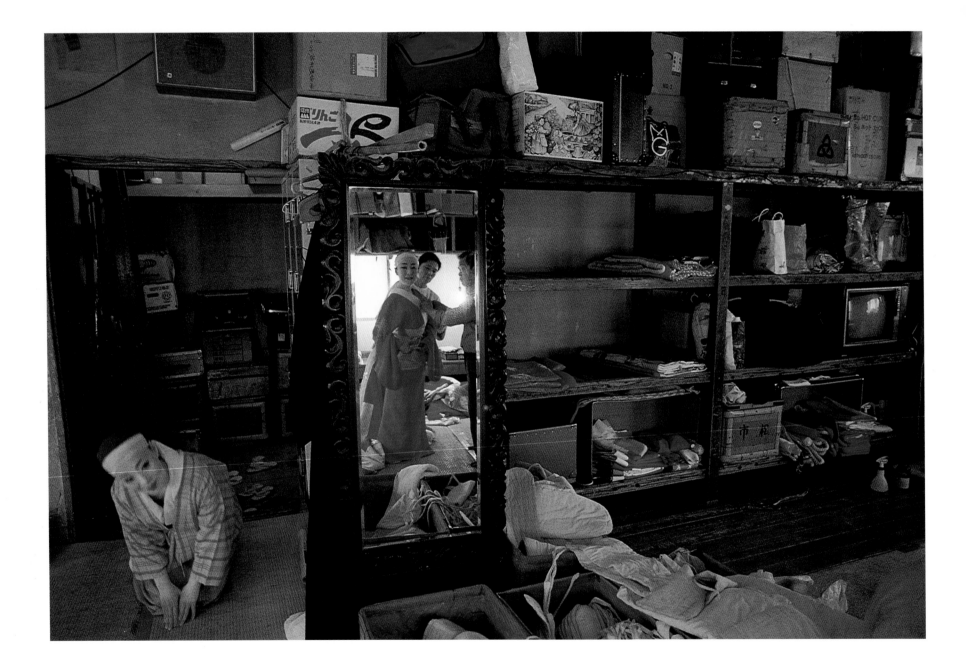

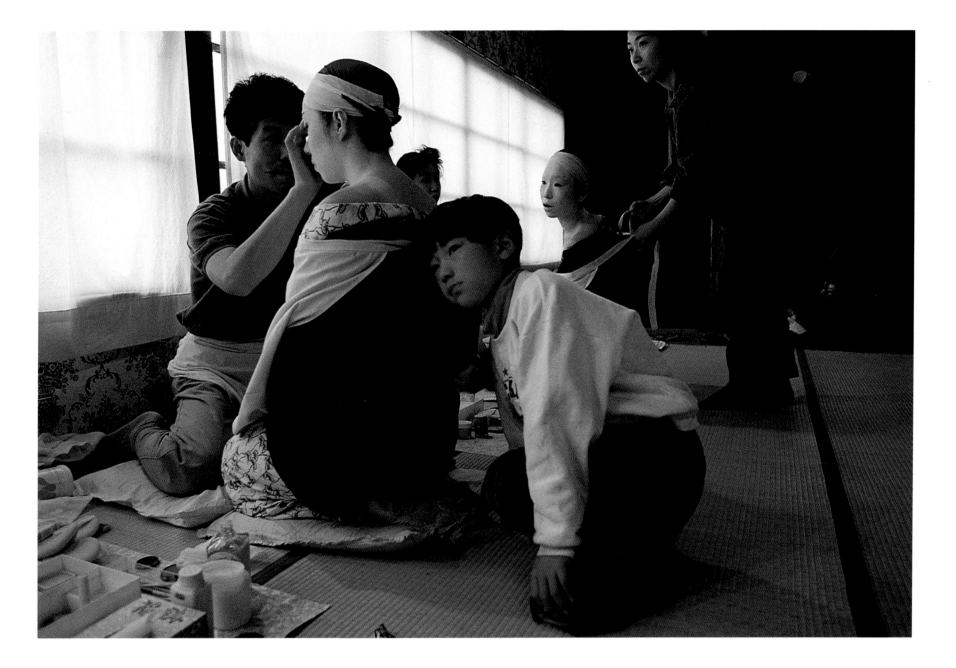

"Everyone wants to know how magic is created. The geisha world has such deep secrets and techniques—I could spend my whole life trying to find its core. After three or four hundred years of history, its secrets are still intact—and always will be.

"It is a dream, a dream come true. The heart of a man is the heart of Japan, and as long as the heart of Japan resides in the geisha world, both will survive."

—Kyoto client

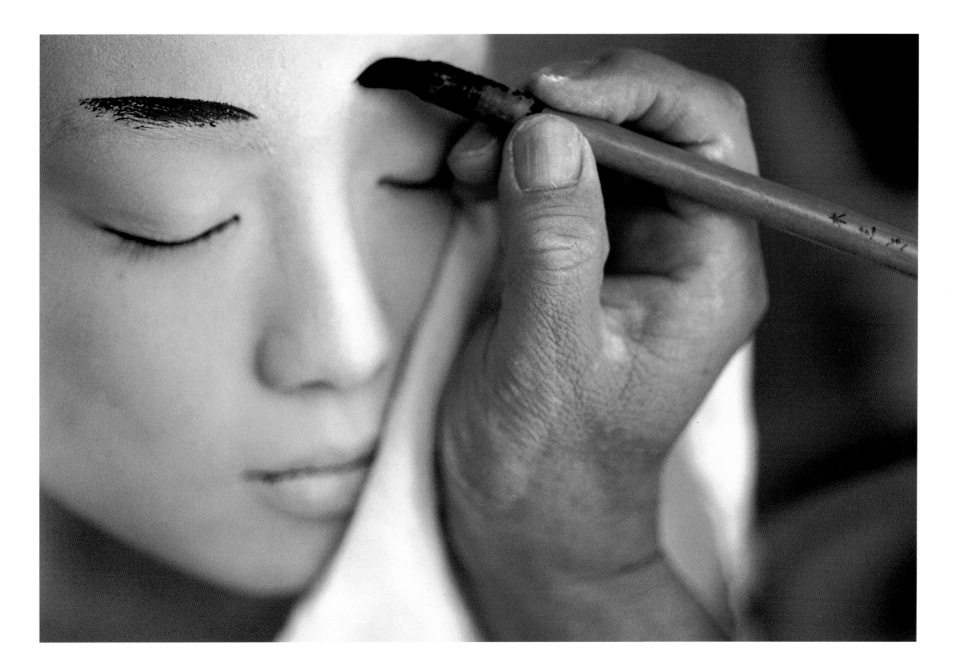

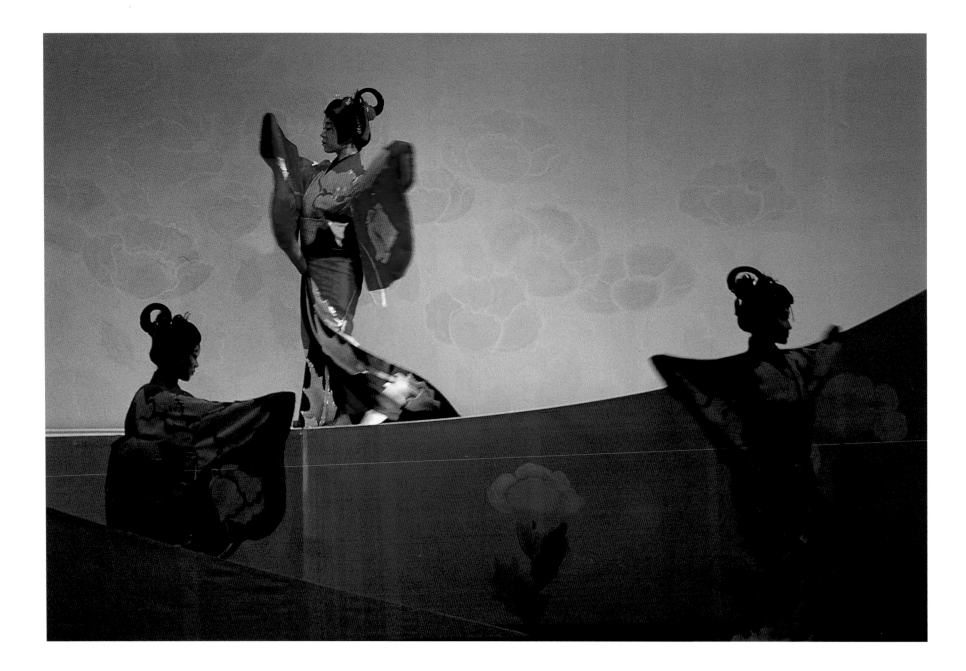

I know she is light and faithless,
But she has come back half-repentant
And very pale and very sad.
A butterfly needs somewhere to rest
At evening.

—GEISHA SONG

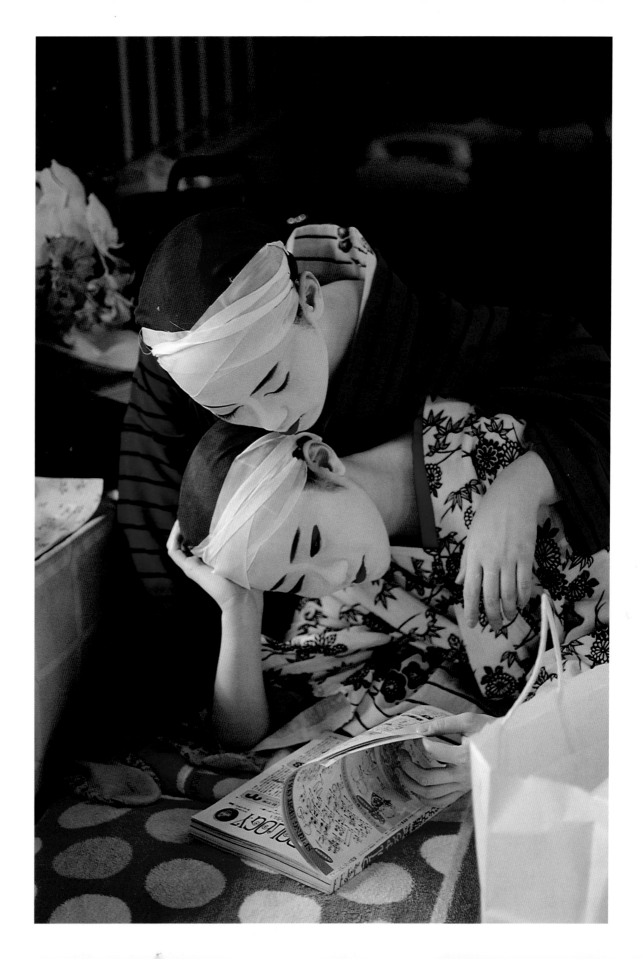

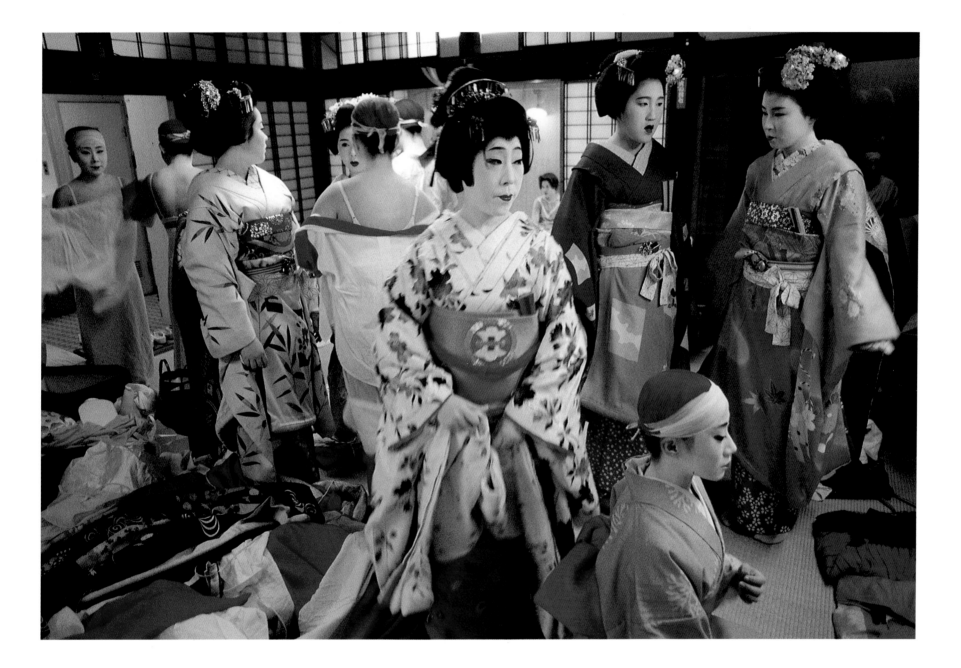

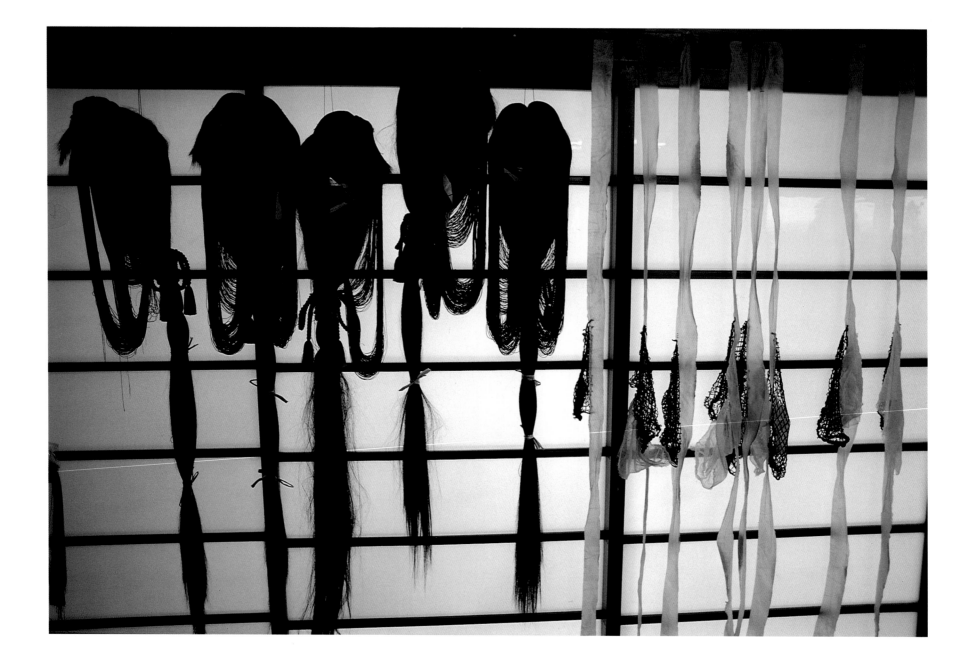

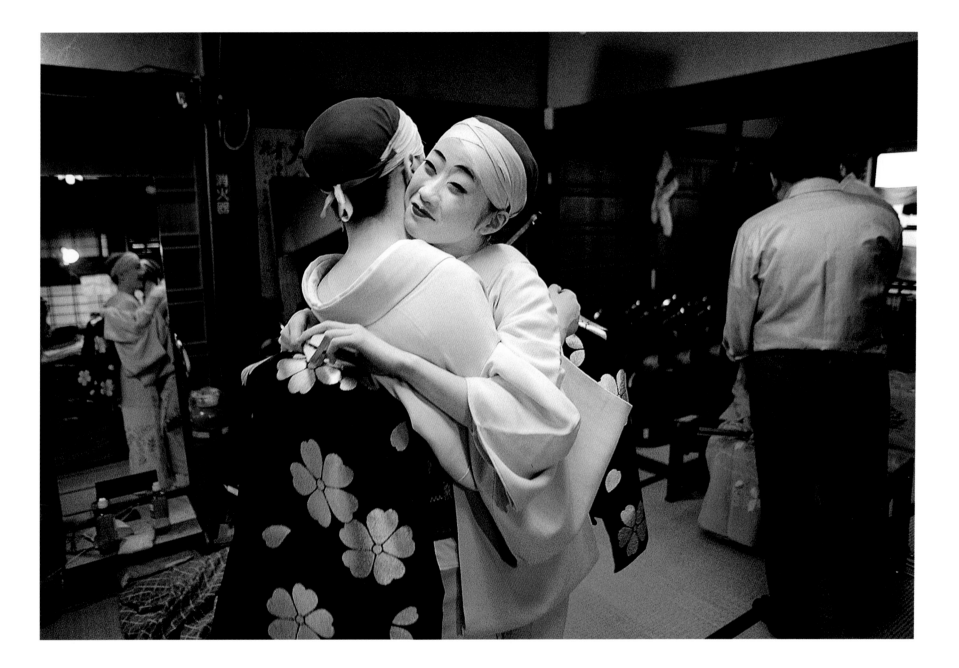

Longing, longing
To be together
I fret my days away.
Ever so once in a while
We steal a night together,
    and part
Longing, longing.

Parting is merely longing,
    never farewell—
The temple bell sounding
    at dawn.

—GEISHA SONG

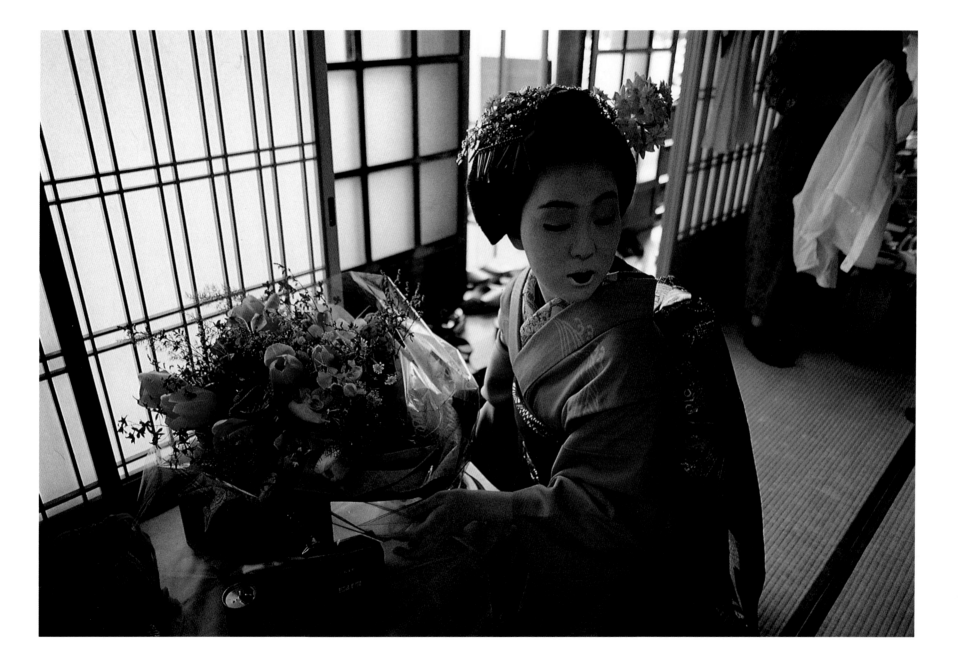

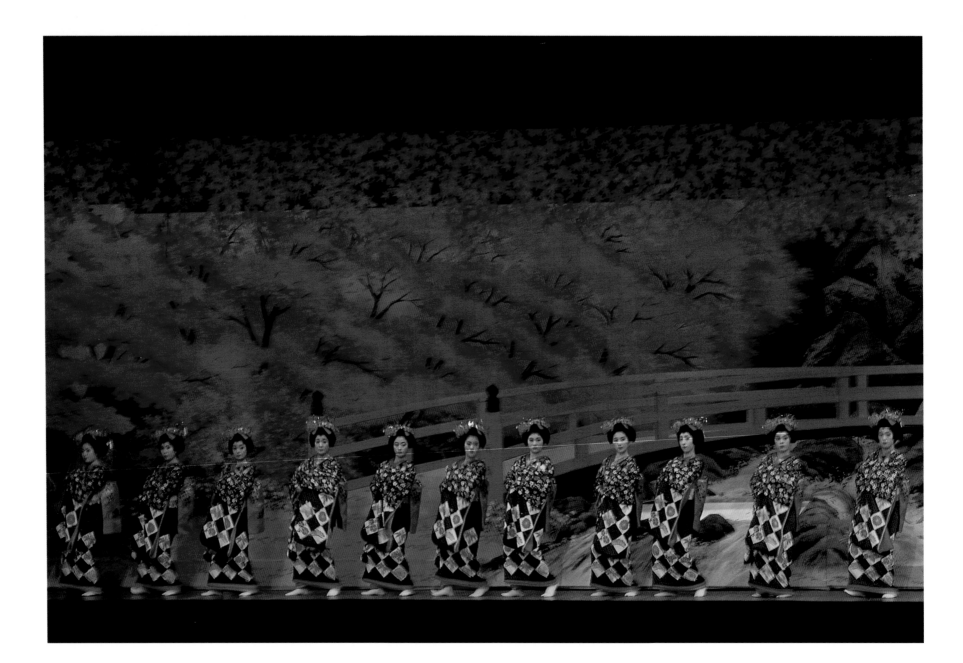

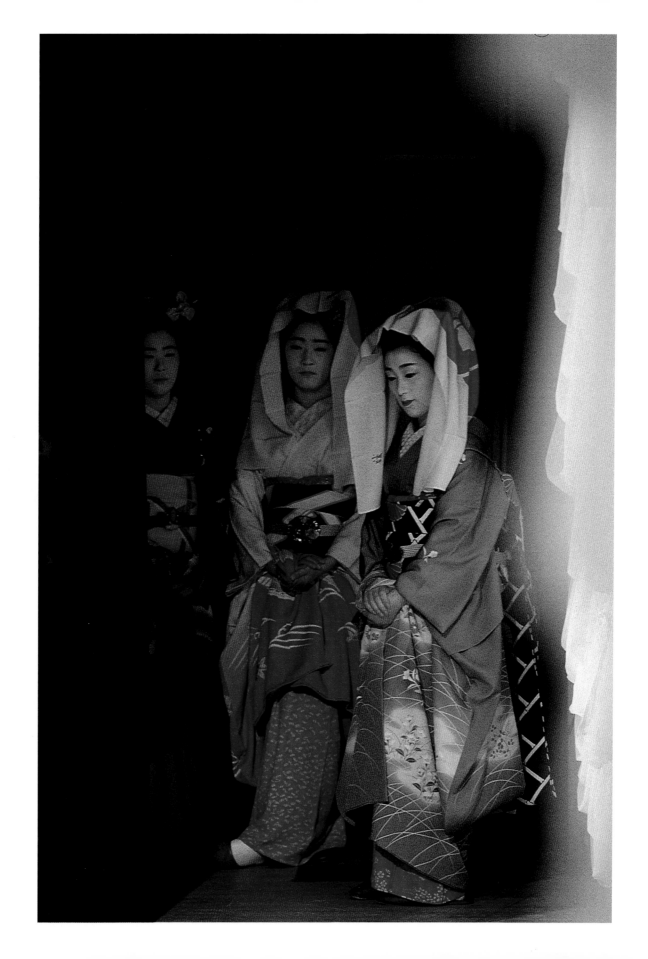

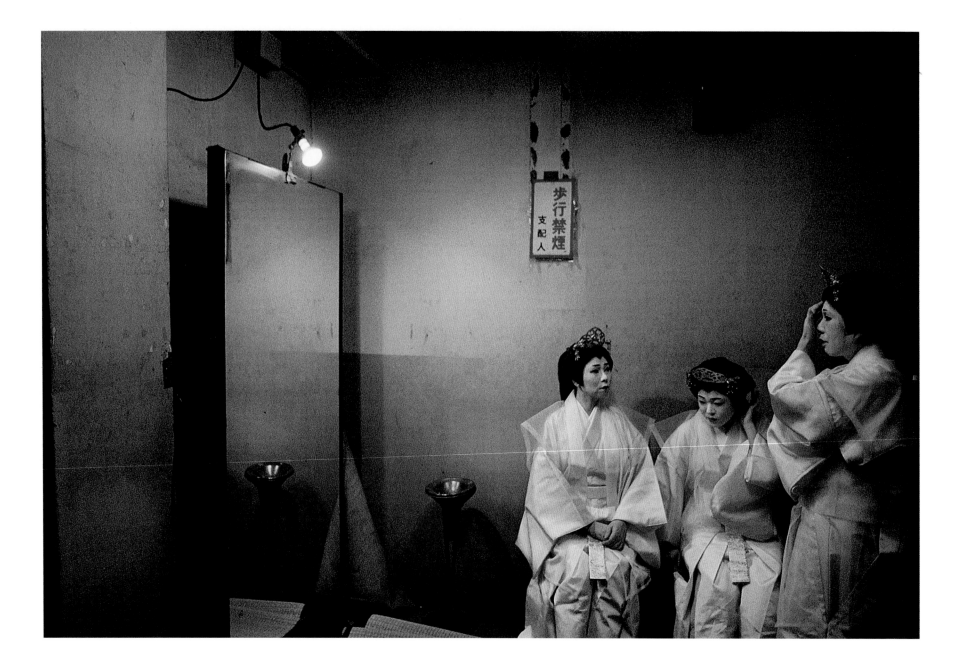

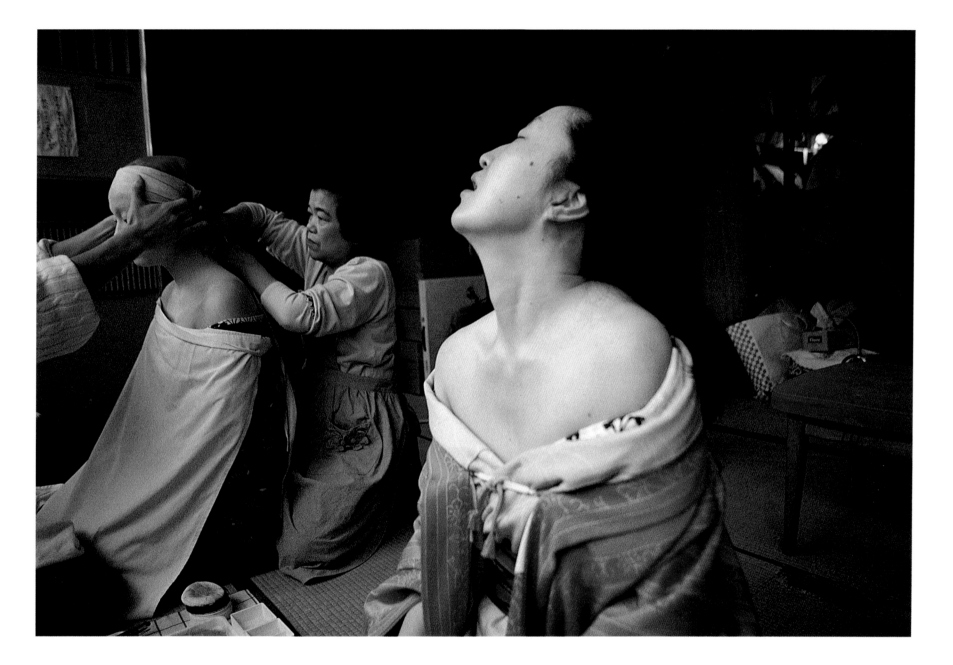

"This world is like Hollywood—the smart young girls concentrate on their skills; the dumb ones look for a man. As in *A Chorus Line*, everyone has something different she wants. But the serious ones stay. In the end, art is everything."

—Mayumi, geisha

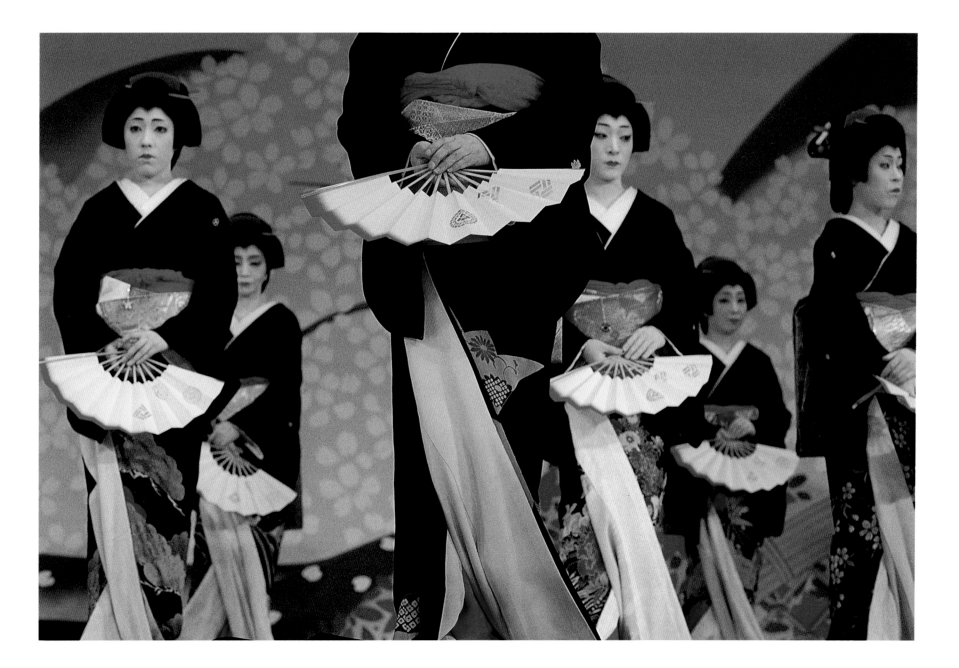

"Geisha will prepare three months for a dance that lasts two days. But people now want their pleasures fast. We must learn the difference between making things efficient and preserving our culture. Clients think they can appreciate these traditional arts just because they're Japanese. But in fact they have forgotten.

"Geisha are a cultural possession of a city and a barometer of its vitality—it would be a real loss not to have them. But in thirty years there will be just a few old ladies left. They are too locked into old ways. It is tradition destroying tradition."

—Dance master

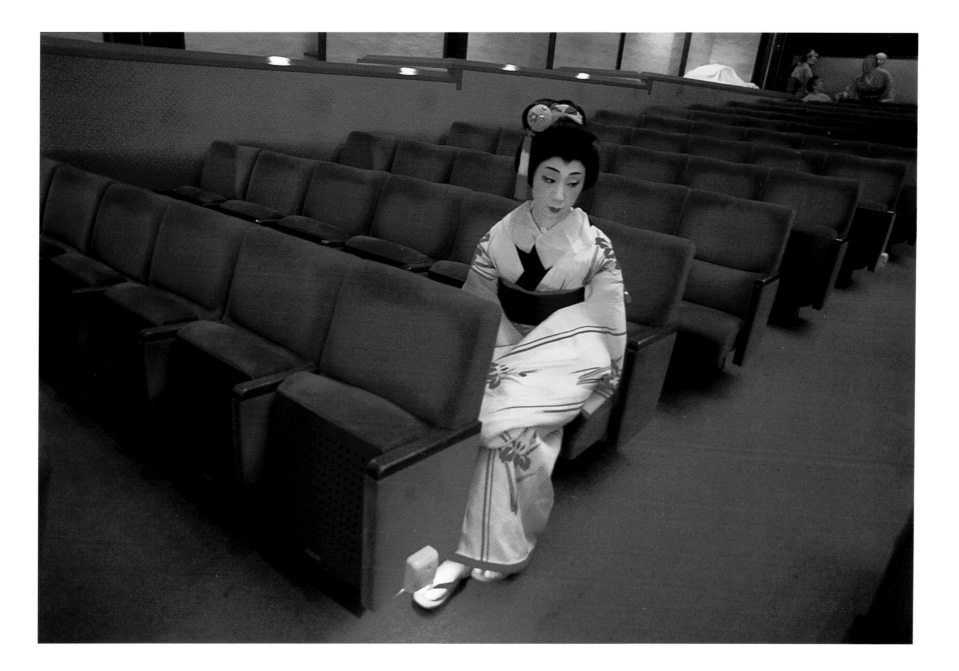

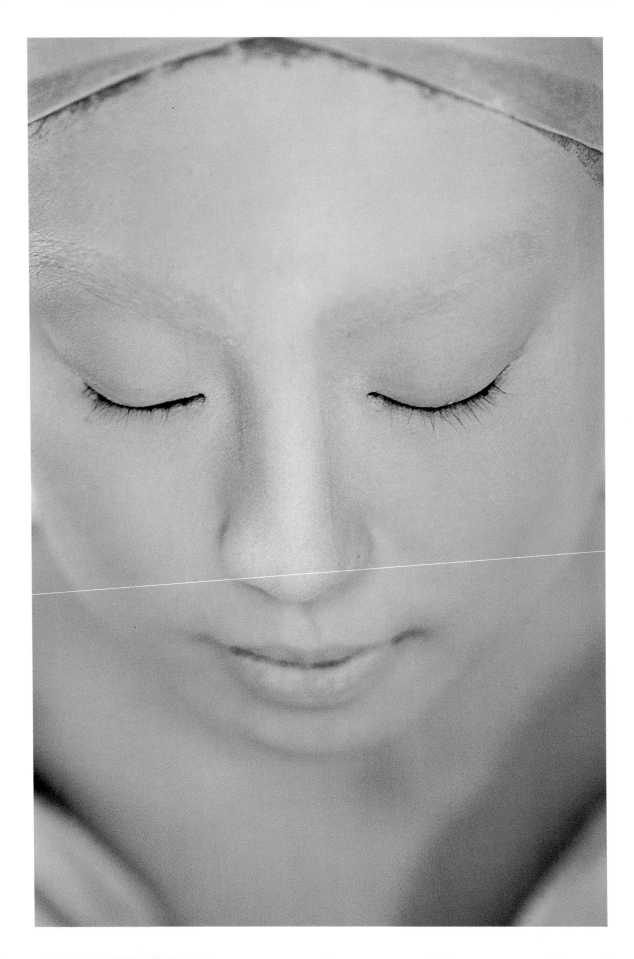

When I see the first new moon
Faintly in the dusk
I think of the moth eyebrows
Of a girl I saw only once.
—ANONYMOUS POEM

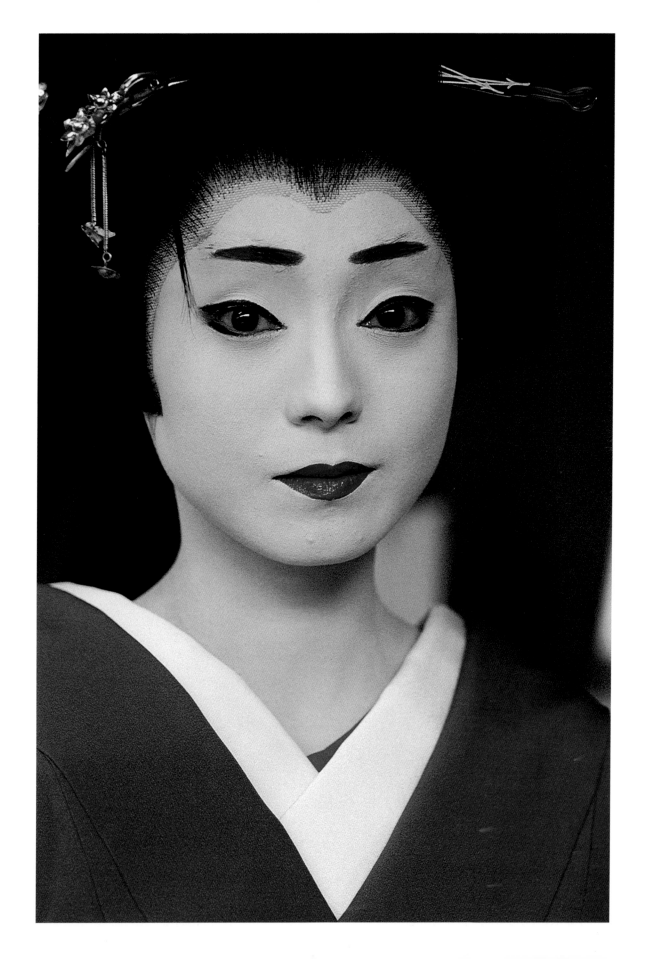

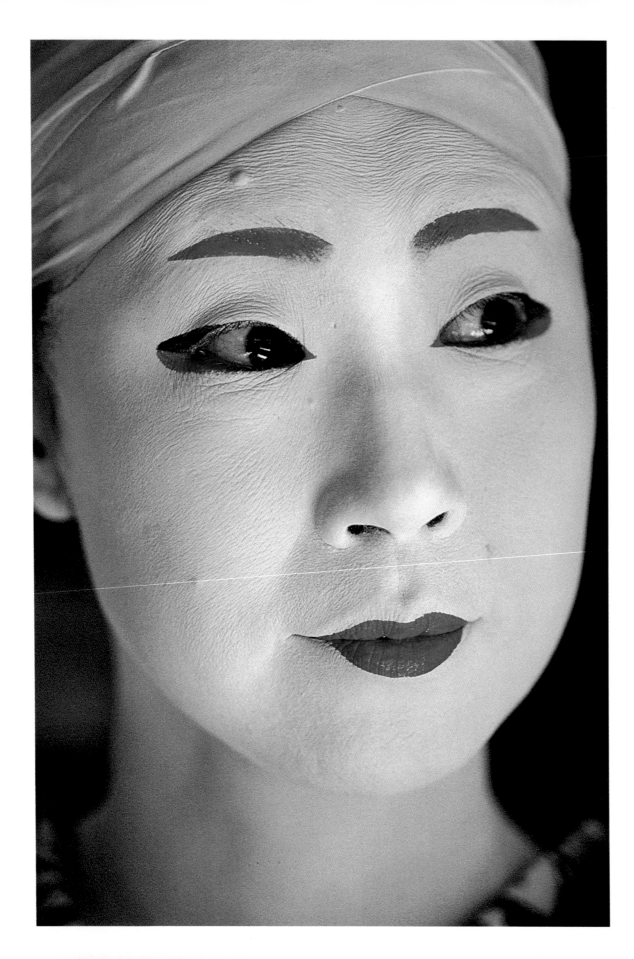

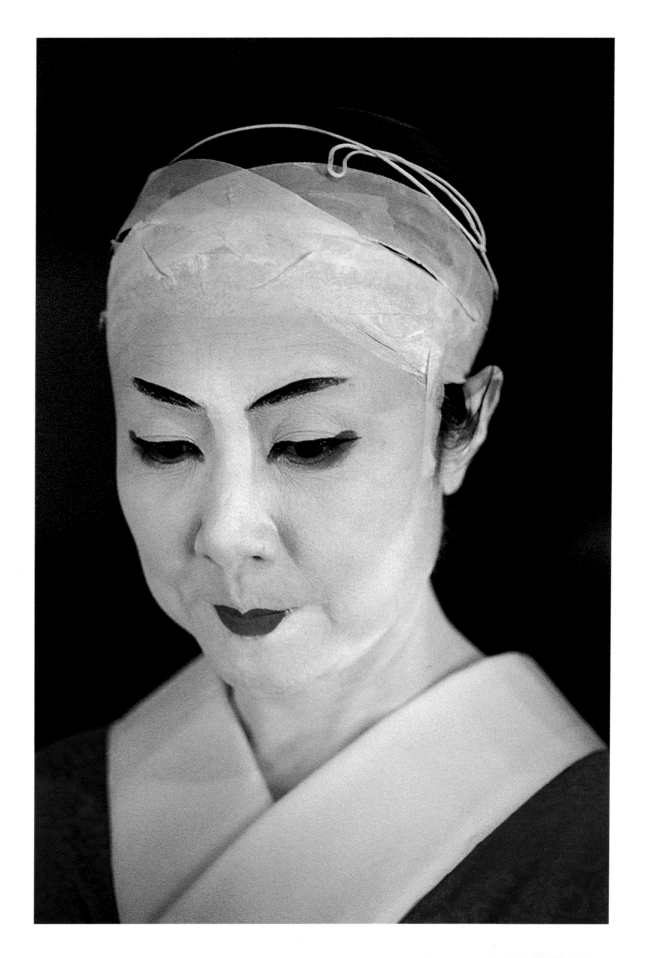

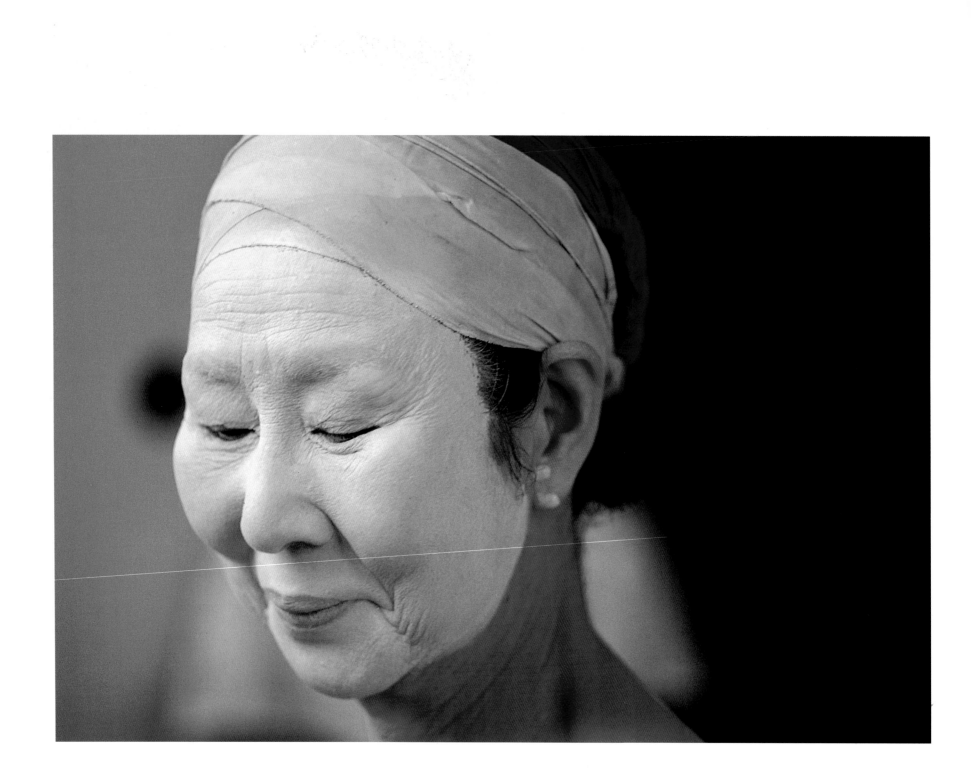

"This is just my business face, not the real me. A geisha on the outside may look very pretty, but inside can be a different story. This world is too difficult for human relationships—you must forget yourself and your true feelings. The elder geisha have built armor around themselves that will never break open. The sad choice of a geisha's life is whether to be a wonderful person in the flower and willow world or a wonderful person in real life."

—Tokyo geisha

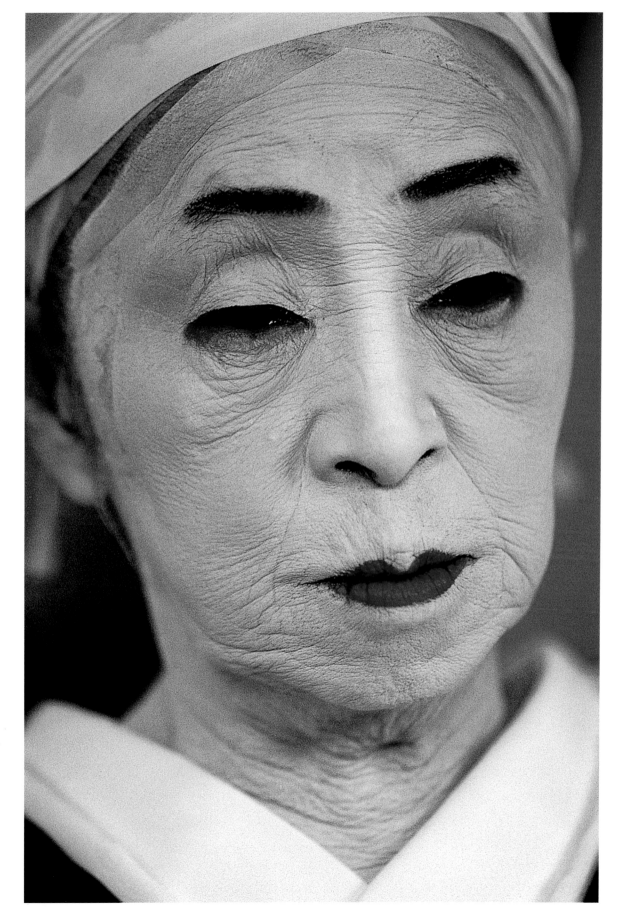

# INSIDE
# THE "PLEASURE
# QUARTERS"

"An *obi* is like a man's necktie. You tie it tight, and you become upright and rigid. I'm like a businessman putting on his suit in the morning, preparing for his daily battle, forgetting his personal life. When I put on makeup and a kimono, I turn into a geisha in my mind also. It happens naturally. In a kimono, I am a professional."

—Tokyo geisha

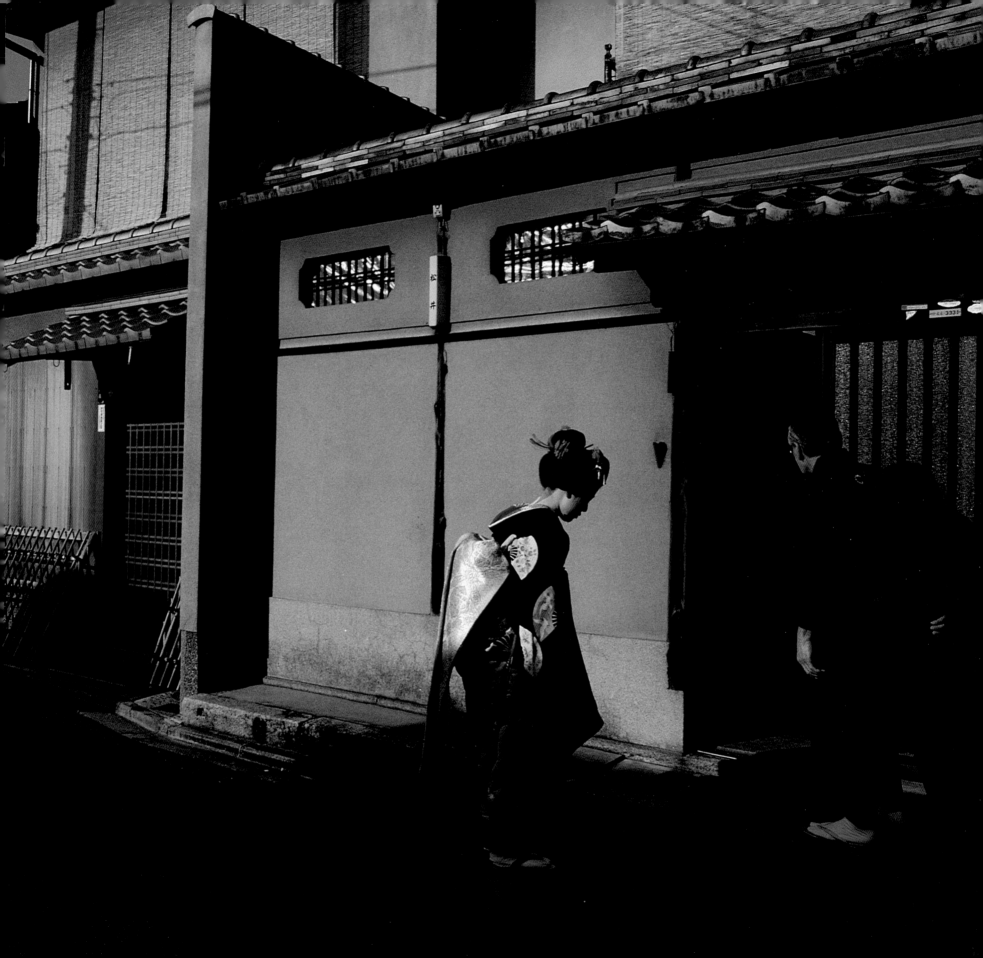

"High praise in the geisha world is the expression *komata no kereagatta hito*. It originally described the beautiful shape of the hairline on the back of the neck. But because we put the makeup on our necks to mirror the shape of the genital area, it now means a geisha with a lovely genital area, a 'beautifully lined place,' who has also developed her *gei* to a high degree. It is the perfect combination of erotic beauty and high artistic achievement. It is what we aspire to."

—Geisha

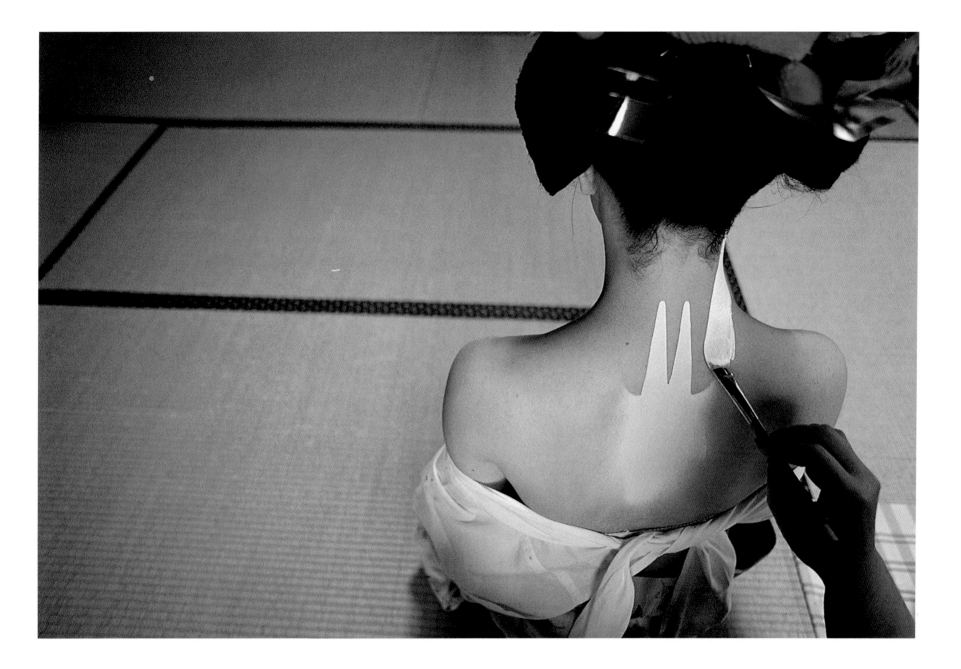

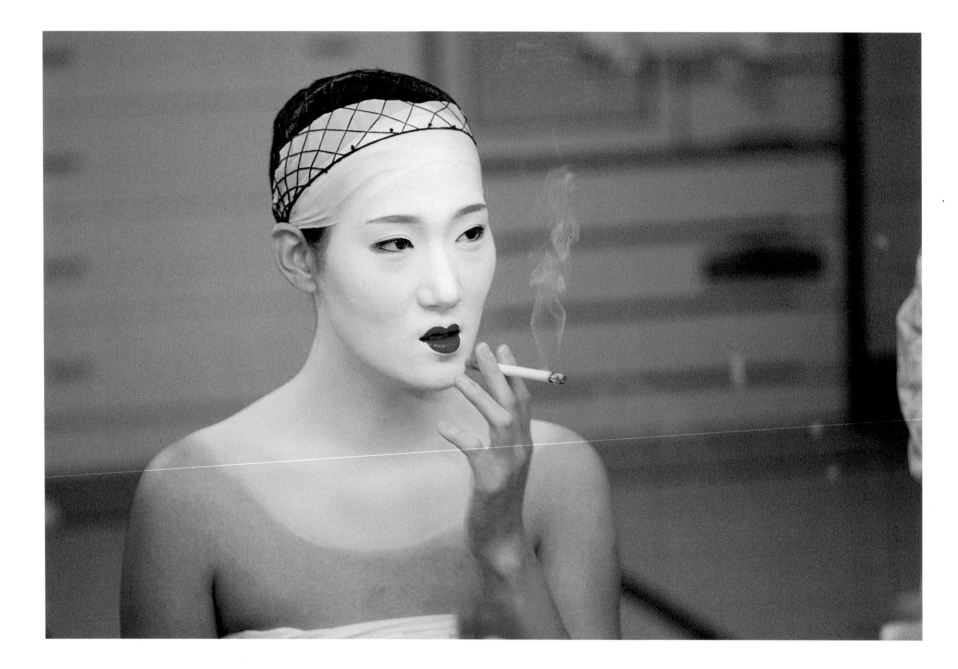

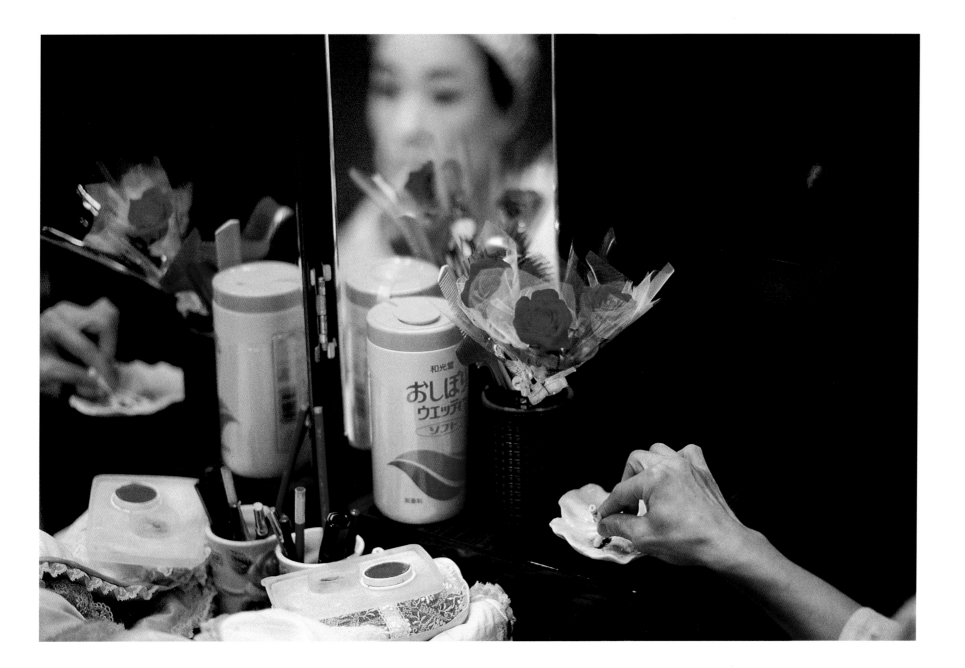

THE FIVE HEARTS—GEISHA HOUSE MOTTO

1. A gentle and obedient heart—to have the heart to say "Yes"

2. An apologetic heart—to say "I'm sorry," and admit and reflect on mistakes

3. A modest heart—to give credit to others for any accomplishments

4. A volunteer heart—to say "I will do it" without thought of benefit

5. An appreciative heart—to say "Thank you."

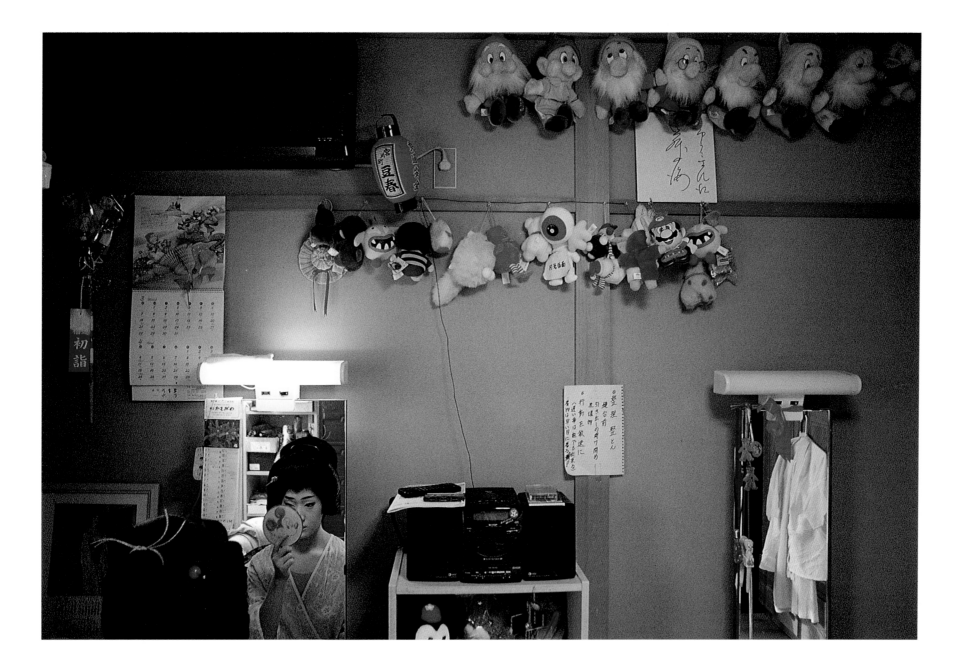

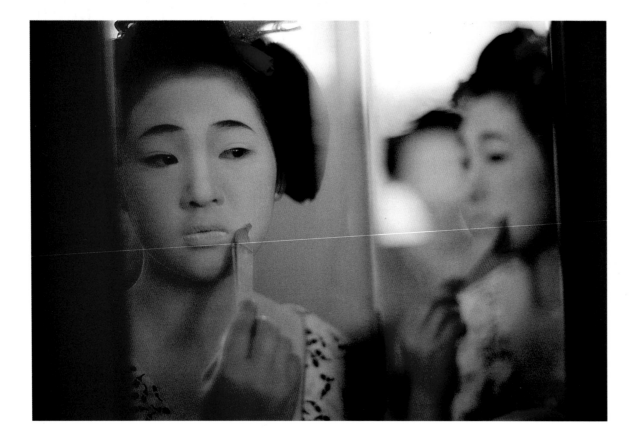

"My secret dream is to become a Buddhist nun. I want meaning in my life. I'm tired of people's eyes. Someone is always looking at me—even when I'm in a taxi, heads turn, people stop and stare, surprise on their faces. I'm tired of pretending to be someone I'm not, tired of flattery. To be a nun would not be that different from a geisha—both worlds require long training periods to strain out your own desires, to reach beyond the life of a normal person. I would love to be thought of as a frank and honest person, speaking and acting as I really feel. But this business won't allow that."

—Kyoto geisha

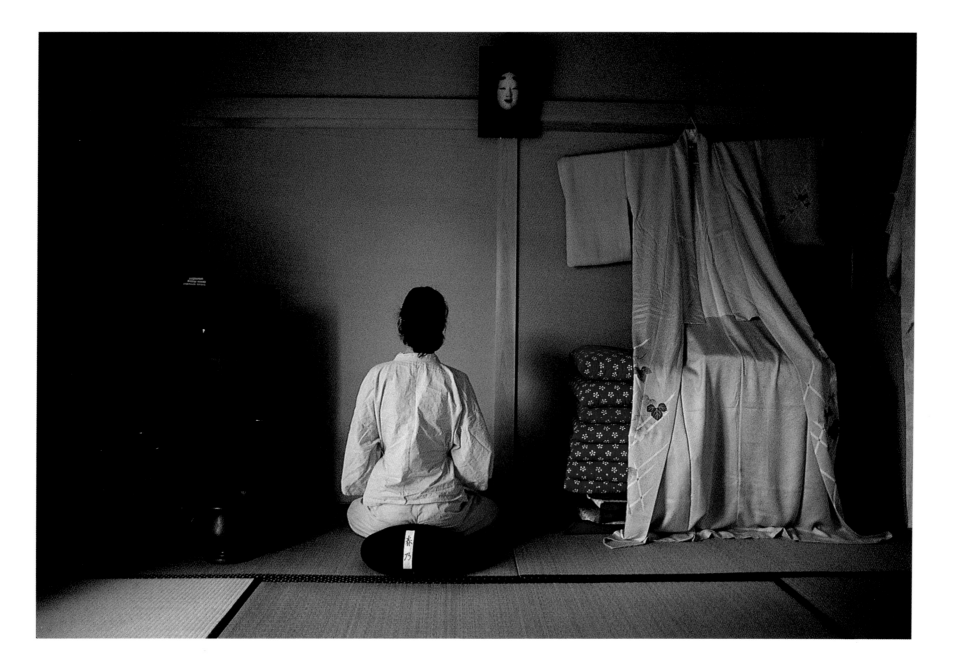

I bathed my snow skin
In pure Tamagava River.
Our quarrel is loosened slowly,
And he loosens my hair.
I am all uncombed.
I will not remember him,
I will not altogether forget him,
I will wait for spring.

—GEISHA SONG

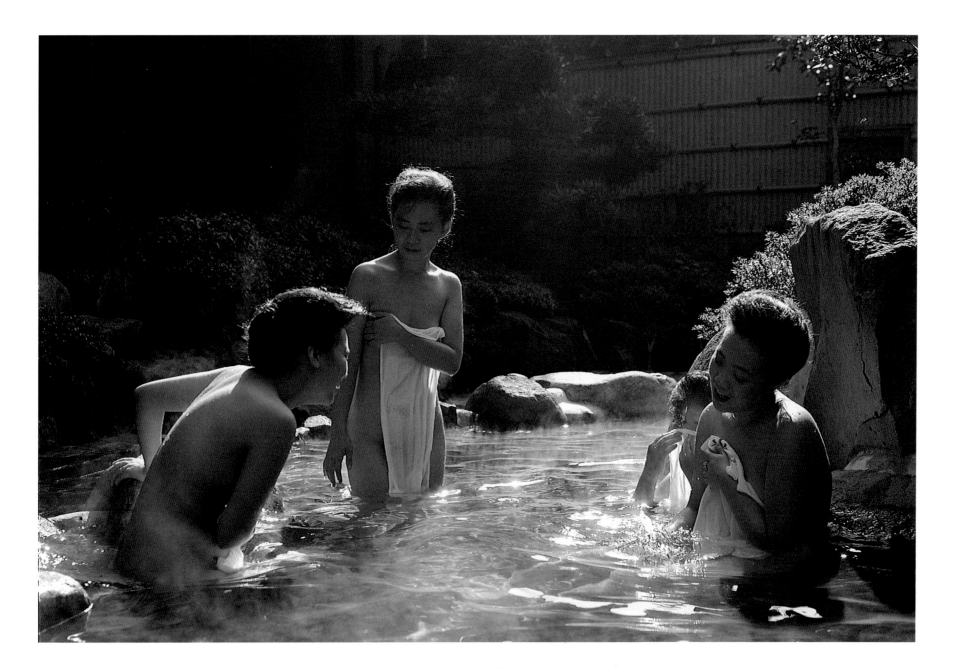

"Red is erotic. The red underkimono symbolizes the change from girl to woman, and we carefully show a trace at the collar and hem. The men find it quite sexy. They love the nape of the neck, the ankle and of course the genital area—but not large breasts. Small ones look better in a kimono. We never bound our feet like the Chinese, but men find the sight of a foot in *tabi* very sensual.

"*Mizu-age* used to be a *maiko*'s first sexual experience, when she changed from a girl to a woman, and she then changed the color of her underkimono from white to red. It was a ceremonial event, decided by the *okamisan* of a geisha house who picked a favorite client, and cost ten million yen. Because she was only eleven or twelve, a virgin and very nervous, it was set up to cause the girl the least embarrassment. By the pillow, they would exchange sake cups as a ritual. The kimono was put on so that a single pull would undo the *obi.* Total nudity was considered crass—that idea only came in with the West—so all she had to do was allow access. The *mizu-age* ritual was forbidden by the anti-prostitution law of 1958, but before that it was decided by the elders, and had to be performed."

—Kyoto geisha

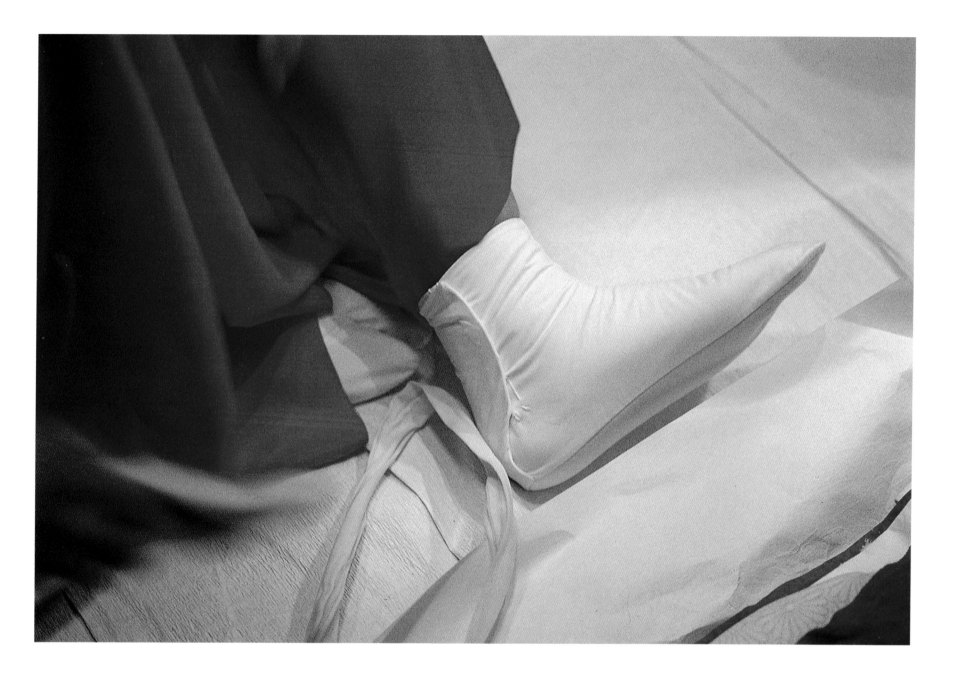

"It's hard to live in a geisha house. There are too many of us in one place, and things get out of control. This world is too competitive, and filled with jealousies. I have superficial friends, not real ones, and other geisha talk behind my back. But I believe in myself. When I was young, everything was new and I loved it all. But it's no longer a dream; it's all too real."

—Kyoto geisha

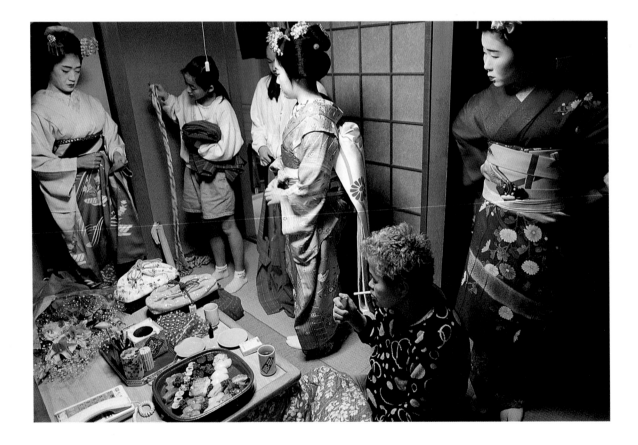

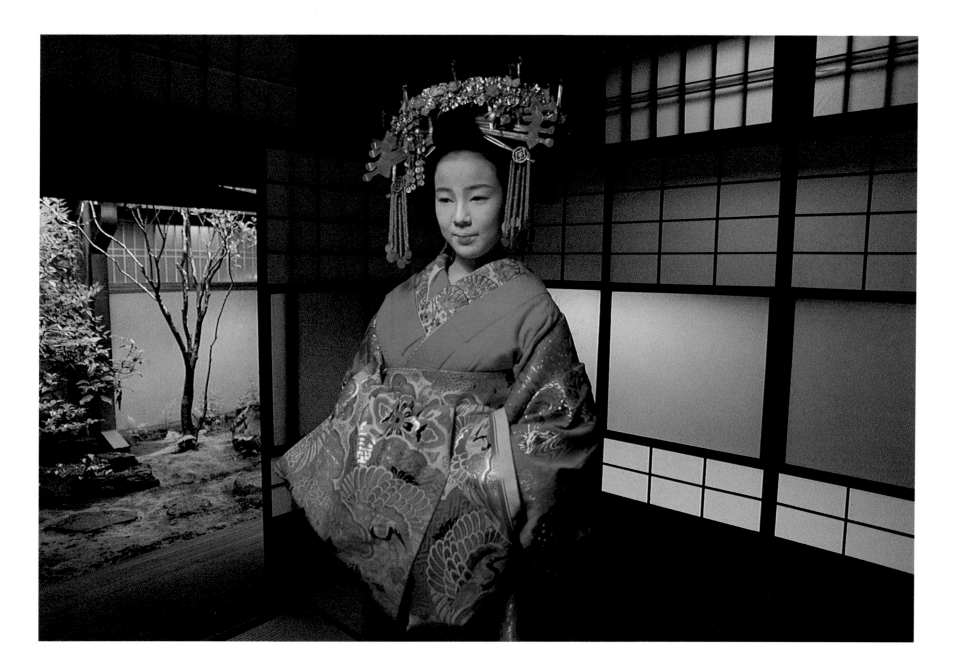

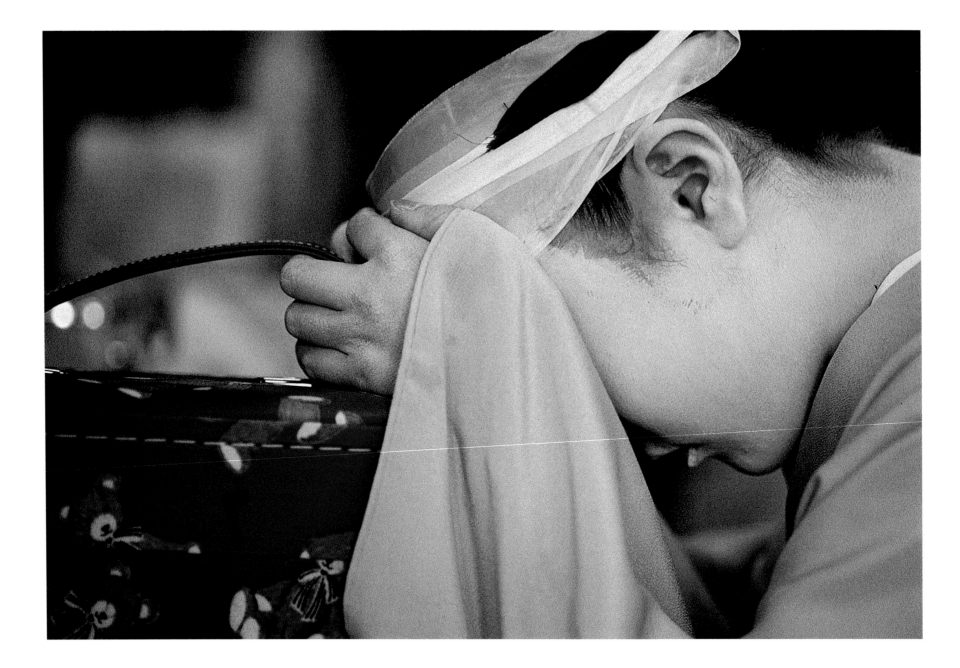

*Waiting anxiously for you,*
*Unable to sleep, but falling into a doze—*
*Are those words of love*
*Floating to my pillow,*
*Or is this too a dream. . . .*
*My eyes open and here is my tear-drenched sleeve.*
*Perhaps it was a sudden rain.*

—GEISHA SONG

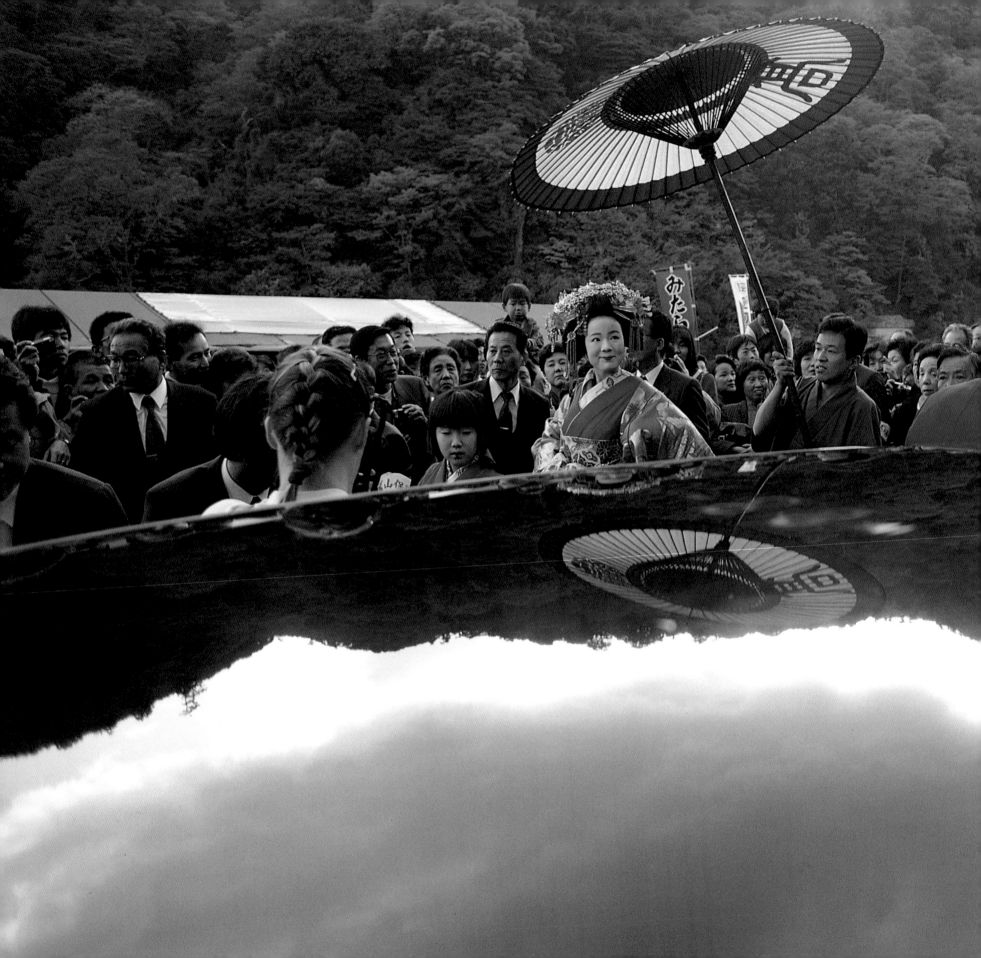

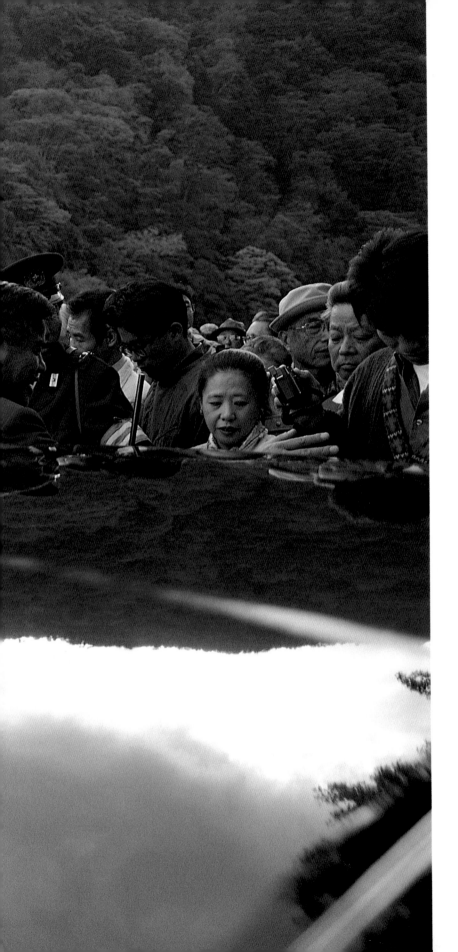

"When I became a geisha forty years ago, I was a hungry spirit—so poor I had nothing but desires. This world was more strict then, a completely vertical structure: heaven and hell. I was surrounded by women who were nasty and mean but disguised it well. It was not physical discipline, but meanness inherited through the generations, revenge for the way they had been treated. But I would rather they had hit me than what they did. It was like being strangled, but gradually, and with padding so the marks wouldn't show. The women I hated then I hate still, and even now I get nervous when I meet them. If young girls today had that kind of training, they wouldn't last one day, they would surely run away."

—Geisha house *okamisan*

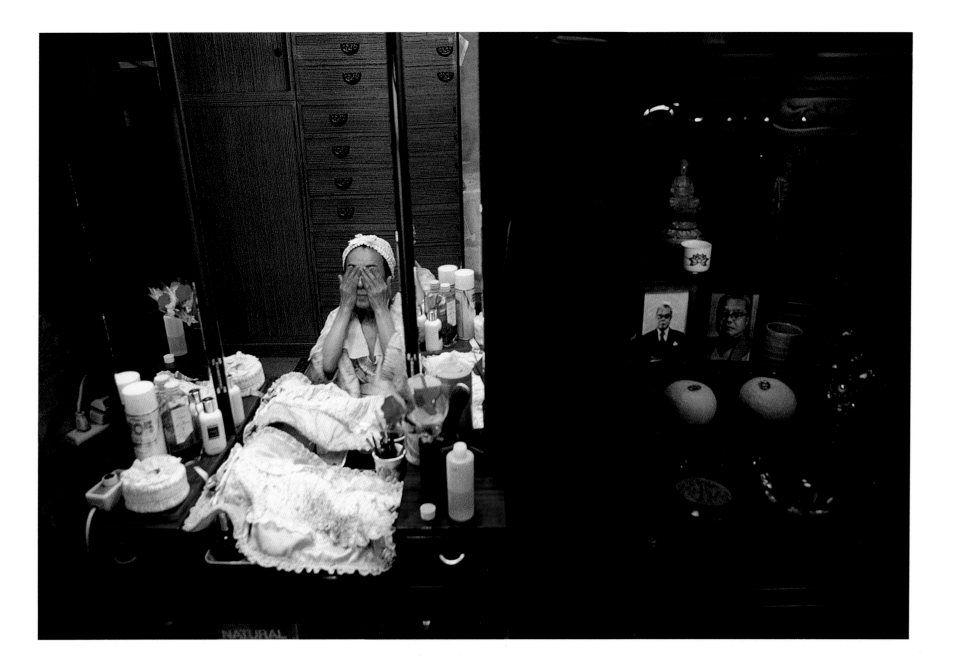

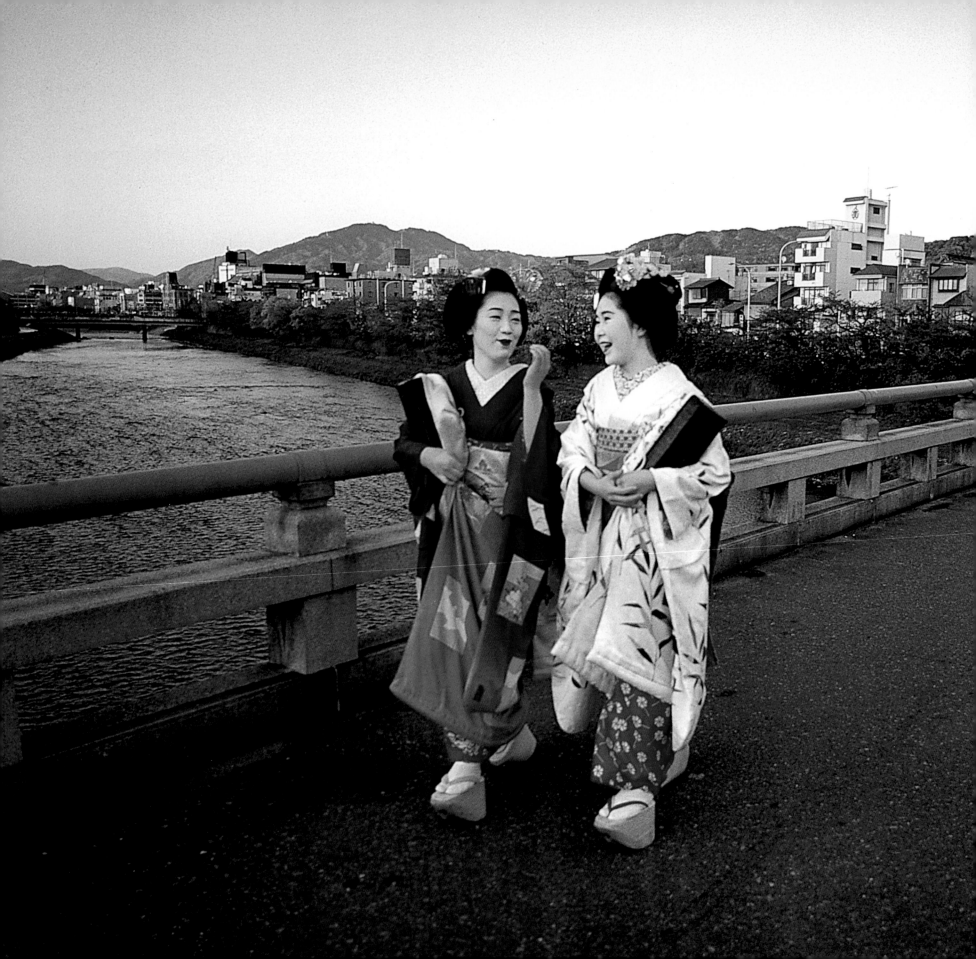

# SELLING DREAMS

"It is a game we all agree to play. The geisha knows it is a game, and the client knows it is a game. We are buying and selling dreams. Clients come here to forget their daily life. So we don't say anything that is not part of their dream. We drink, and if the client wants us to dance, we dance, and if he wants us to sing, we sing. And we speak of things that have nothing to do with wives."

—Tokyo geisha

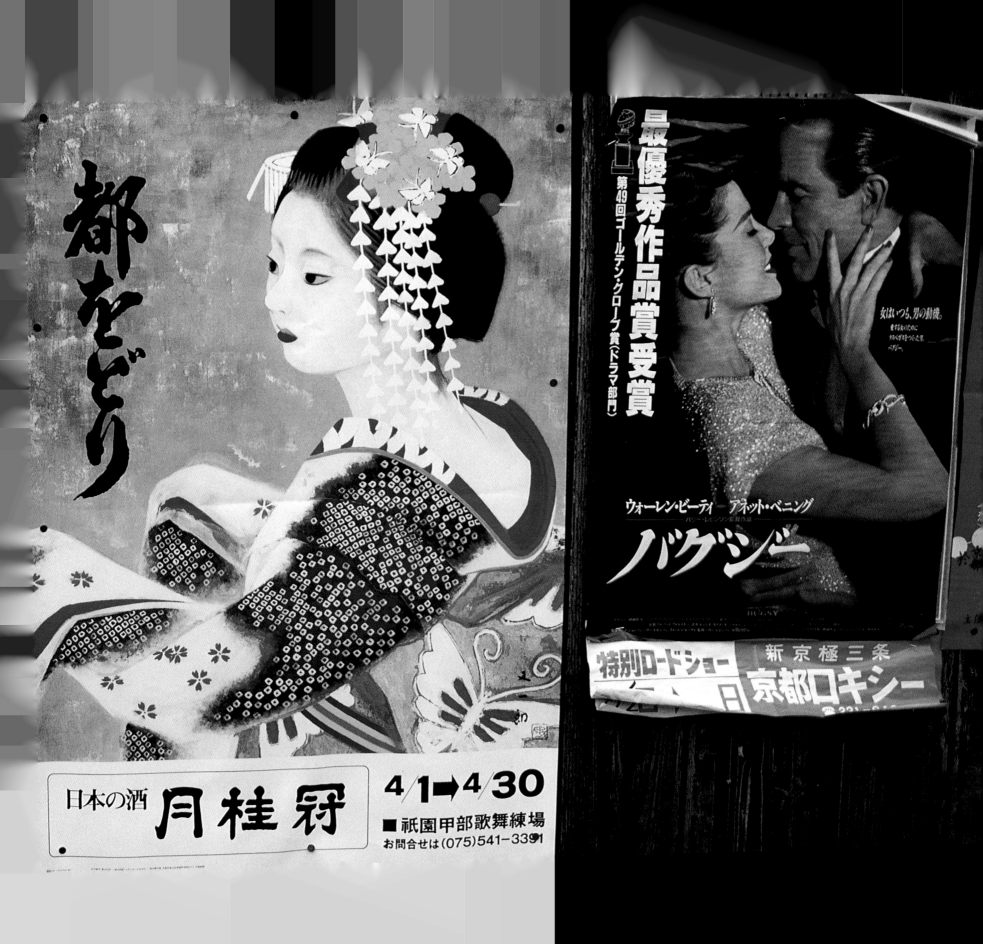

"In America, party invitations go out to 'Mr. and Mrs.' Here they don't; they go out to 'Mr. and Partner.' A geisha is my partner—kind of my wife, my sweetheart and my darling combined. You can't often change your wife, but you can change your partner anytime. How lucky I am to be a Japanese man!"

—Kyoto client

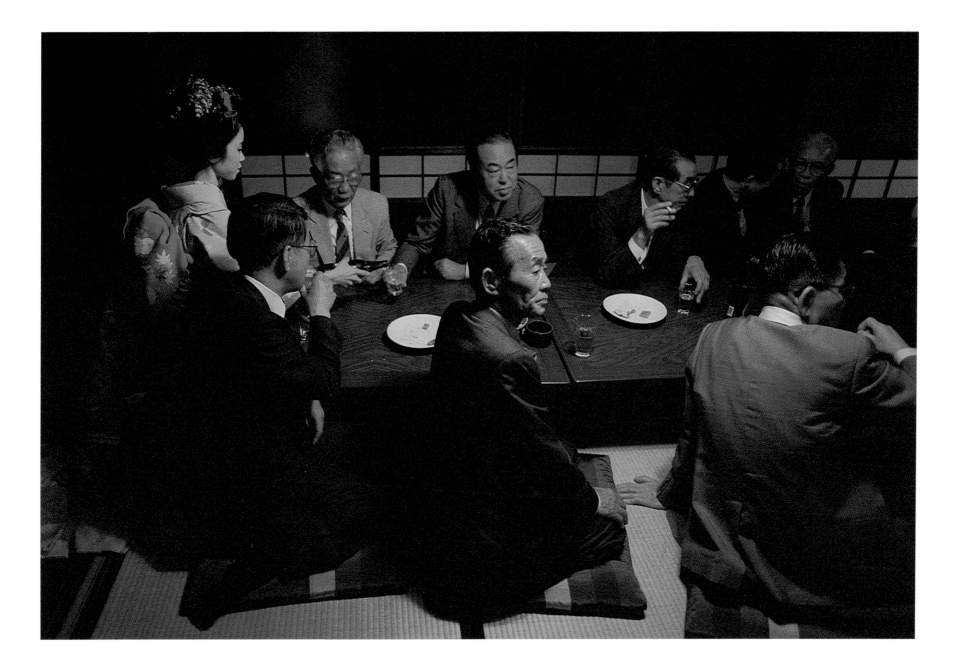

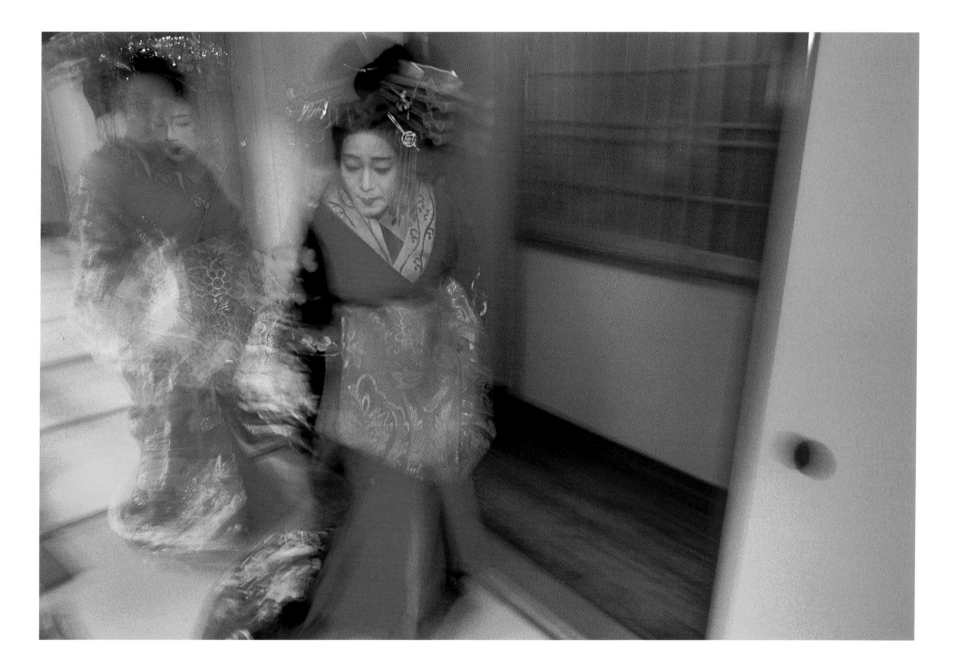

The spring wind whispers
Bring in fortune!
Fragrant plums breathe
Drive out devils!
Is it rain?
Is it snow?
I don't care—
We'll go on this evening and tomorrow too,
Drinking ginger sake.

—GEISHA SONG

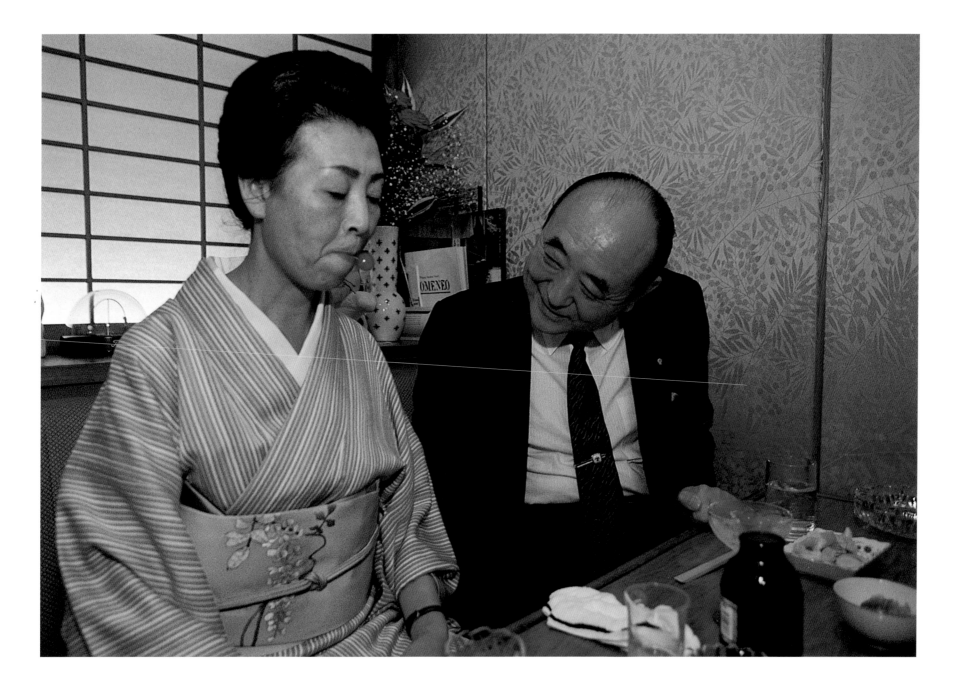

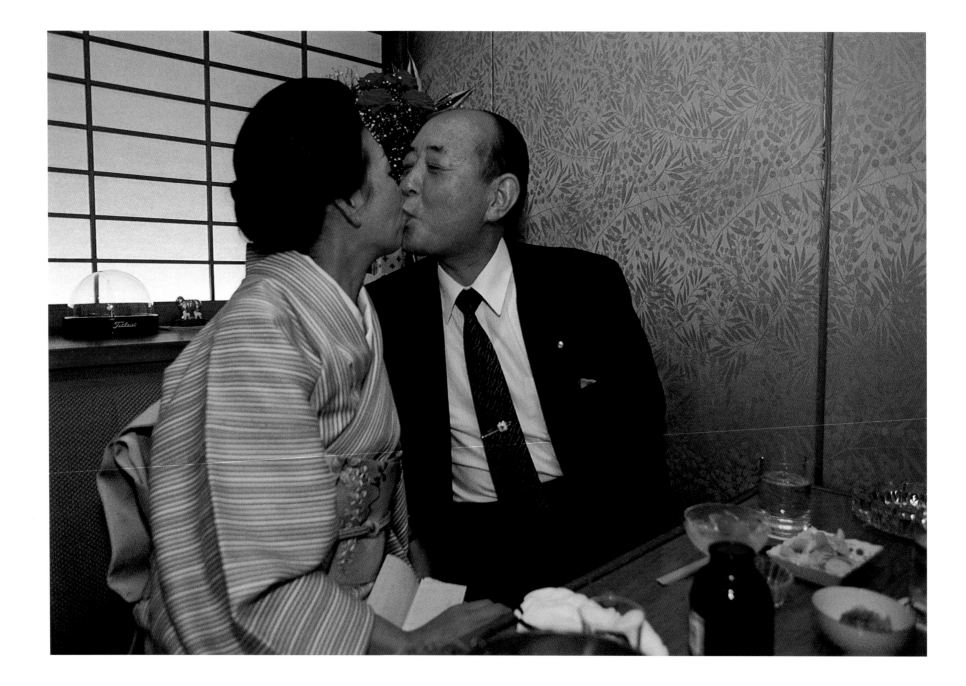

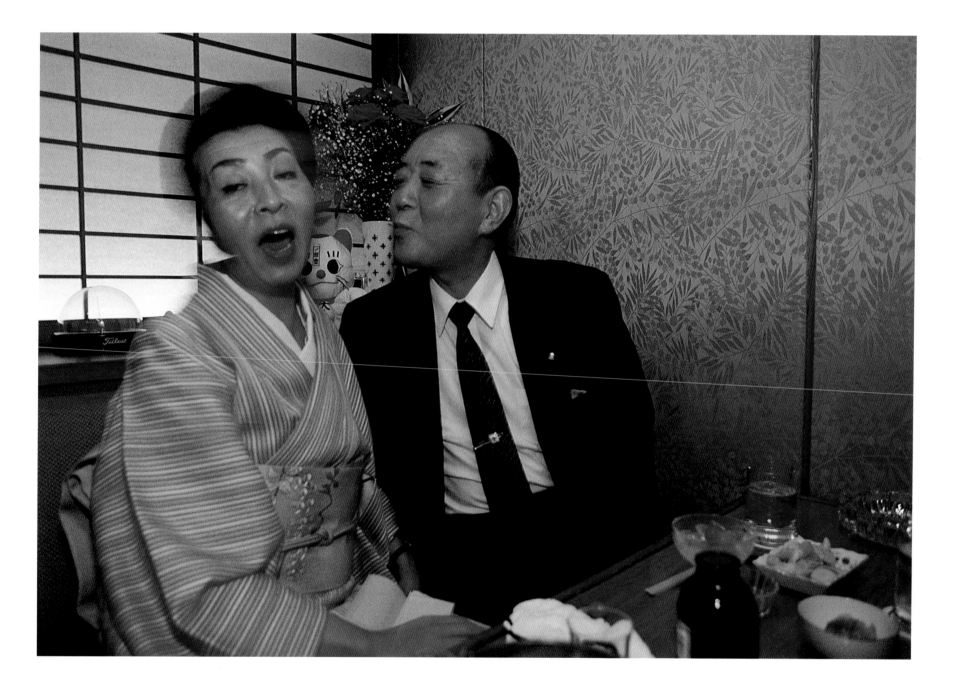

"My father played with geisha in Gion for seventy years—he started at thirteen and continued until he passed away at eighty-three. He brought me at age fourteen. That was my father's way, and my grandfather's way. . . .

"I want my family life to be peaceful, so I'm afraid to be charmed. I have no interest in remembering the names of the geisha. When I meet one who behaves and performs well and talks smartly and says, 'Oh, please remember my name,' I say yes, and she says, 'Please call me again,' and I say yes—but I won't do it. If I called her the next time, and again and again, as a male I could not trust myself. I want to keep my family happy and together, so I must make my own rules. But no one can say what will happen tomorrow.

"I have seen how geisha prepare their makeup, but I don't like to. I want the romantic ideal, not the reality. I don't want to know their tricks. I don't want to know their sad stories. I want to keep it as a dream, and they want to keep it as a dream for me. That's the business."

—Kyoto client

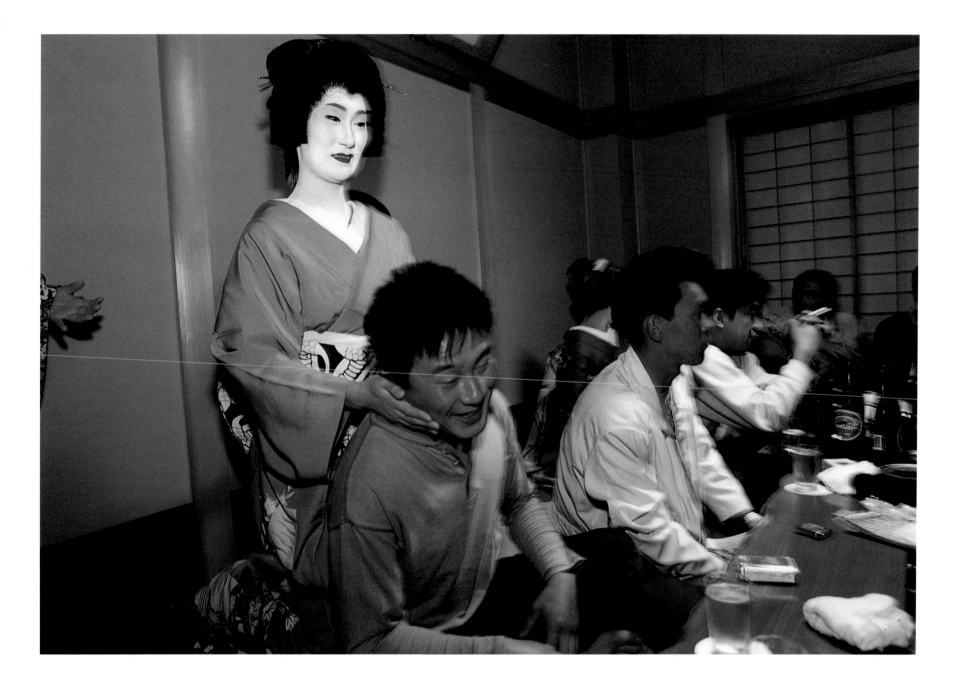

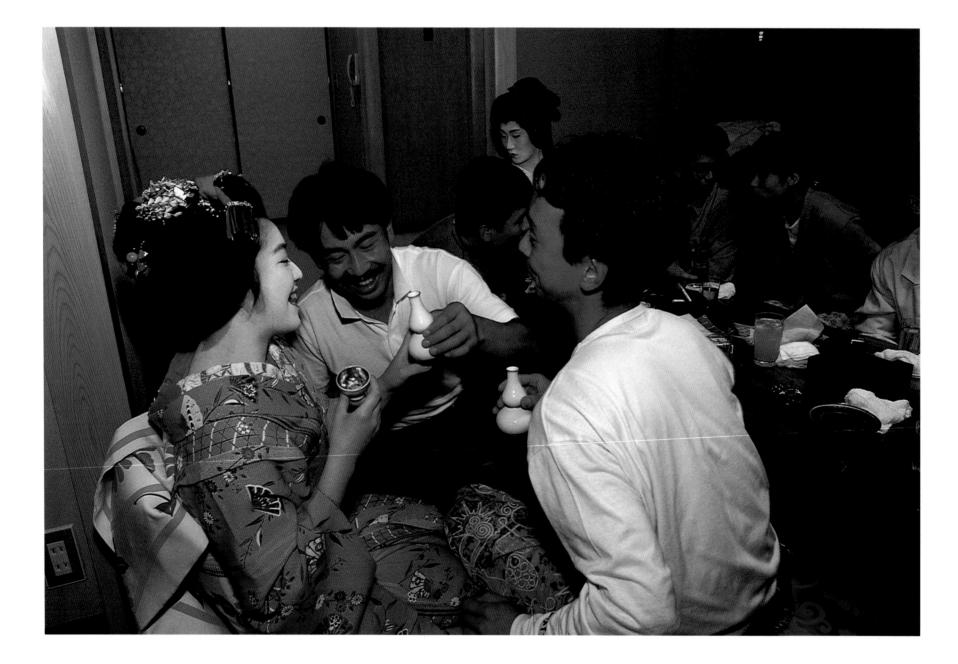

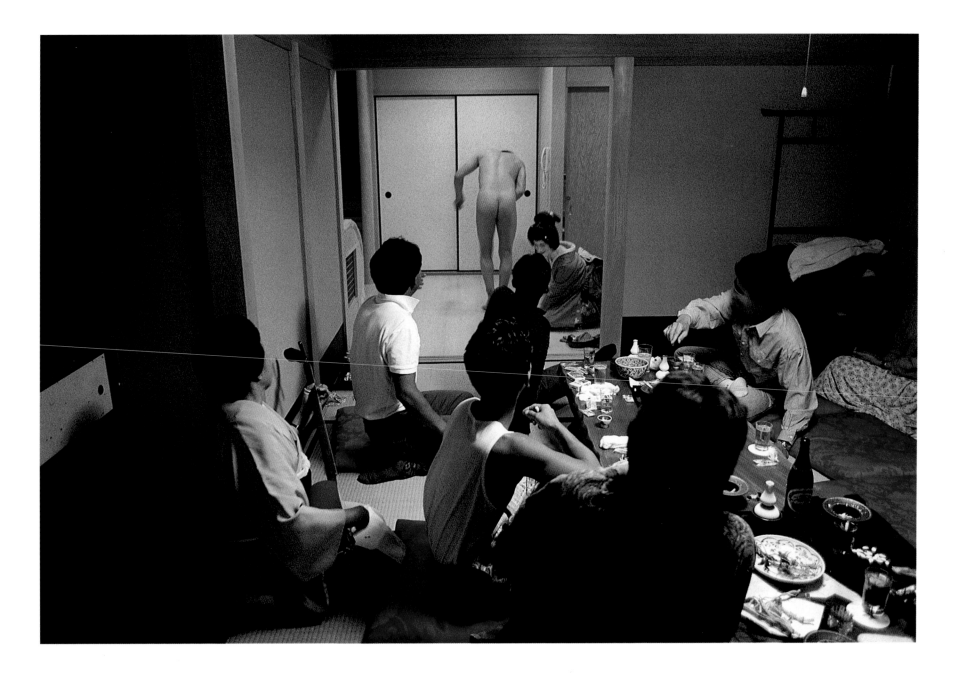

"A man becomes a geisha's patron as a secondhand way of acquiring art. He just acquires the person who performs the art."

—Mayumi, geisha

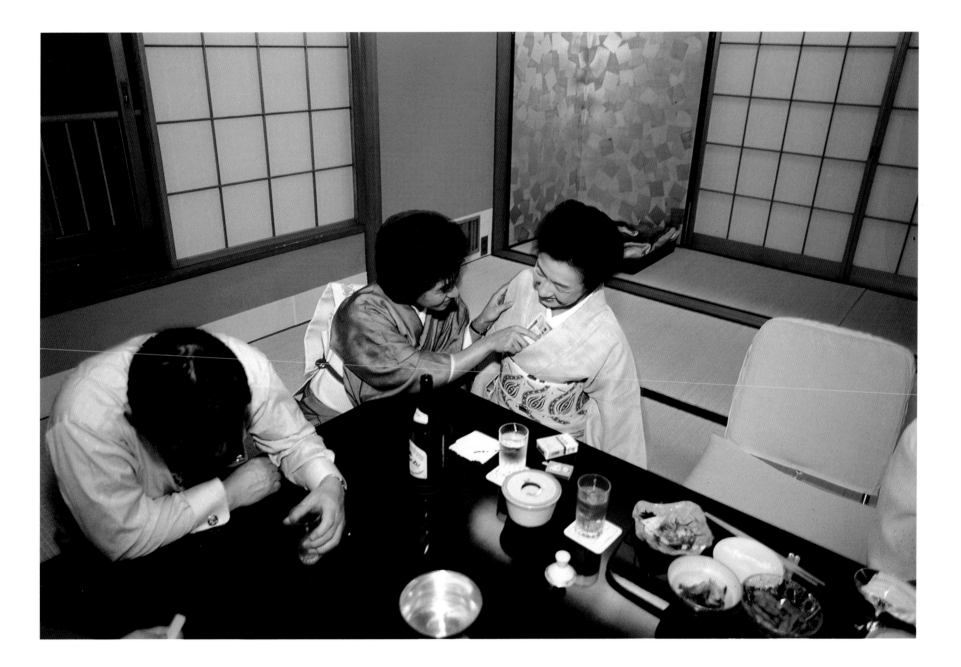

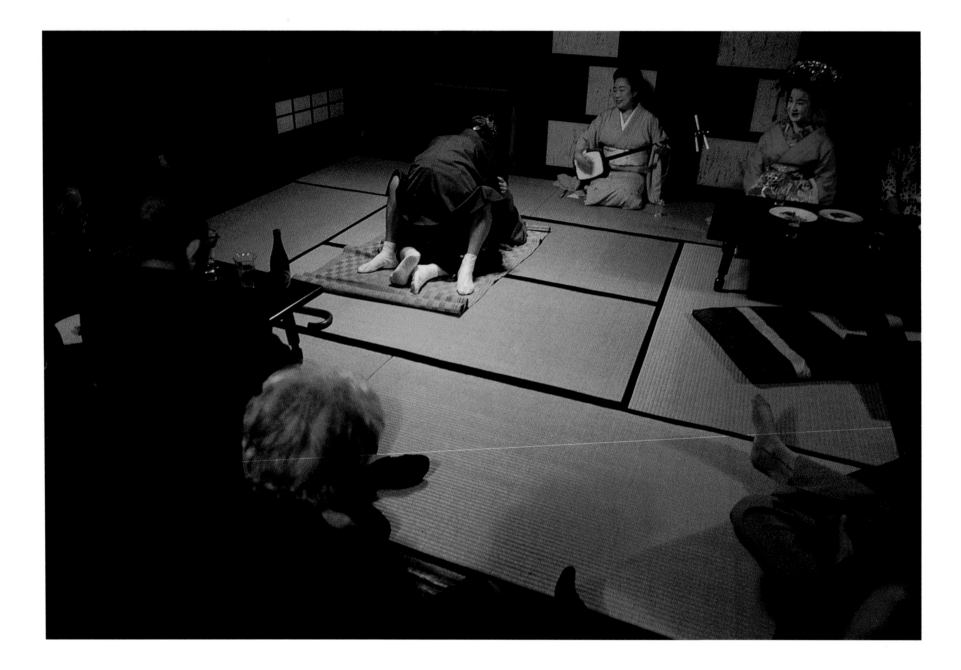

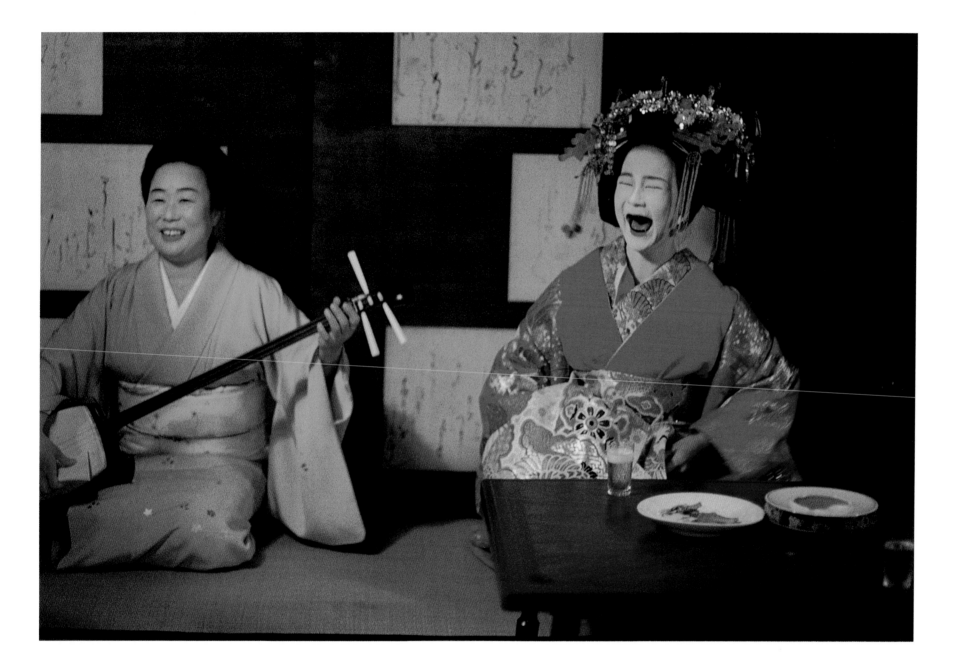

Your heart
Flip-flops and changes
Like a marionette.
There's someone in the shadows
Pulling your strings.

— GEISHA SONG

The night is black
And I am excited about you.
My love climbs in me, and you ask
That I should climb to the higher room.
Things are hidden in a black night.
Even the dream is black
On the black-lacquered pillow
Even our talk is hidden.

—GEISHA SONG

"I am the 'second wife' [mistress] of a very rich man. I don't know why he wants a second house and a second wife—probably to relax. I only do things to please him and make him happy. I always think, 'What is best for him? What is he thinking about right now? What does he want?' He likes that kind of attention from me.

"I know he loves his real wife in his own way—he loves us both, but his real wife comes first. I've completely come to terms with that. I don't want him to leave her—if he could do it once, he could do it twice. And I just want to keep this life. I would have no rights, nothing, if he left.

"I wanted children, but I've given up. Maybe I don't need them. My 'husband' says, 'If there are children in my real house and children here with you, how can I be the child?' He comes here to be a child, and I treat him like a mother would.

"In this world, the man holds the higher position, and the woman follows him. That's the way it should be. I must help and support him, but not let him know. That is woman's virtue: to be strong on the inside but not let it show."

—Tokyo geisha

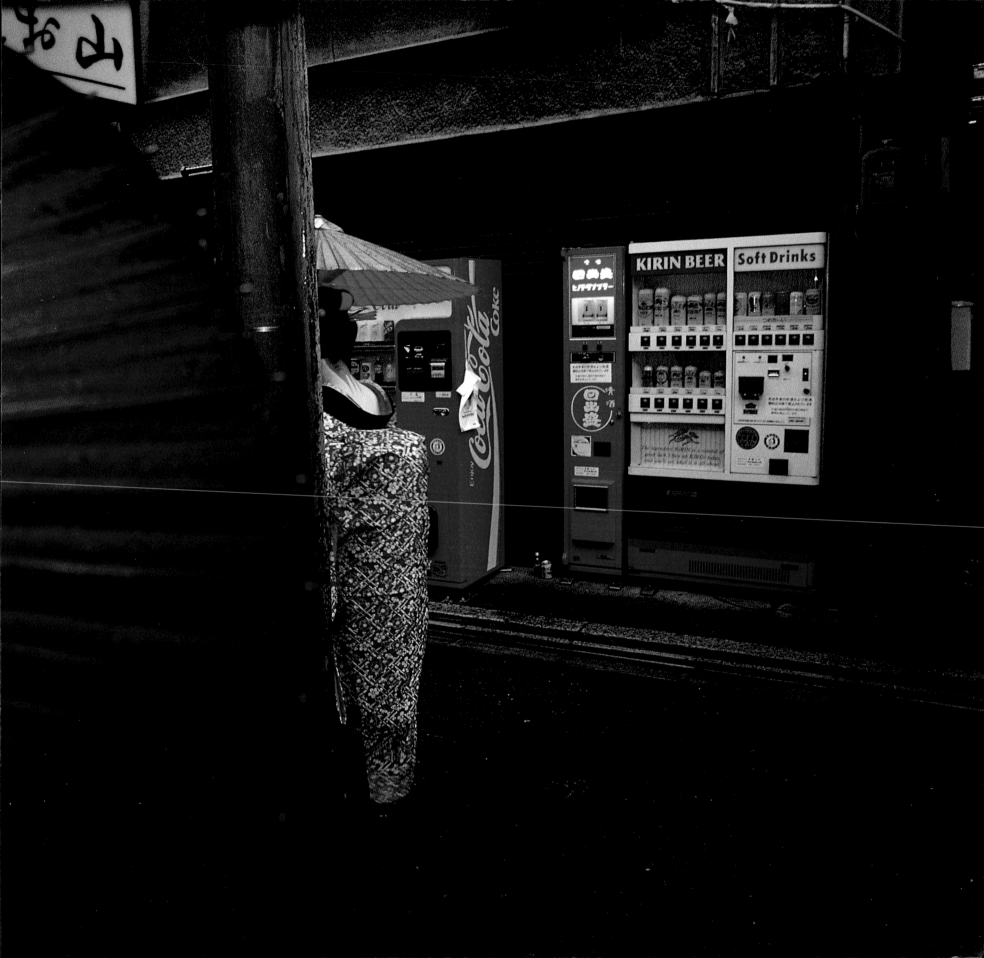

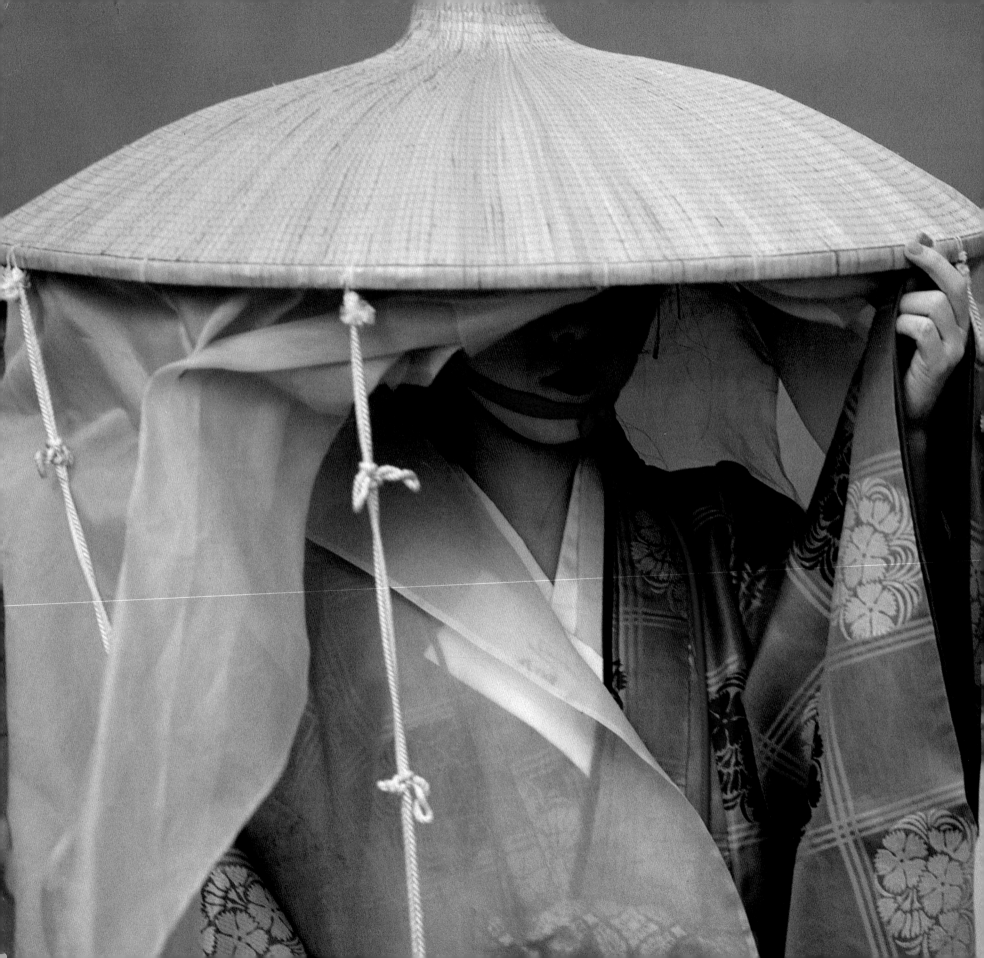

How cruel the floating world
Its solaces how few—
And soon my unmourned life
Will vanish with the dew.

—IHARA SAIKAKU,
"The Woman Who Spent Her Life in Love"

"Everyone in the flower and willow world is here for some personal reason—either she was born into it or there was some suffering at the heart of it. In the past, a daughter would be sent to a geisha house to keep her family from debt or starvation, just as in Vietnam and Cambodia and Thailand today parents are selling their children. But there, it is mere prostitution, just the selling of bodies. There is no pride for the girls, no skills to call their own, nothing to emerge with. But in the geisha world, the saving grace is that even though you may enter with nothing, you will come out with your own skill, your world of art. That's a huge thing you gain. And what I have just said is what you should have as the final thing in your book."

—Mayumi, geisha

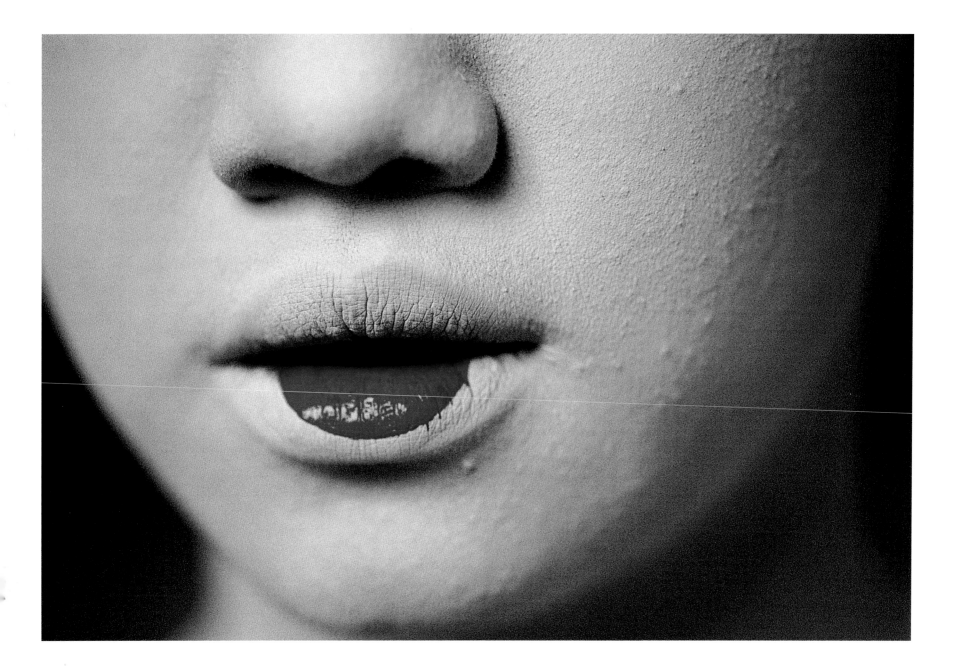

# BIBLIOGRAPHY

I have consulted many sources for my introductory essay, but I am particularly indebted to Liza Dalby's definitive book *Geisha*, for its wealth of information and insight. The following is a list of books recommended for those wishing to do supplementary reading on geisha.

Bornoff, Nicholas. *Pink Samurai: The Pursuit and Politics of Sex in Japan.* London: Grafton Books, 1991.

Buruma, Ian. *A Japanese Mirror: Heroes and Villains of Japanese Culture.* London: Jonathan Cape, 1983.

Condon, Jane. *A Half Step Behind: Japanese Women Today.* Rutland, Vermont, and Tokyo, Japan: Charles E. Tuttle, 1991.

Crihfield [Dalby], Liza. *Kouta: Little Songs of the Geisha World.* Tokyo: Charles E. Tuttle, 1979.

Dalby, Liza. *Geisha.* Berkeley: University of California Press, 1983/New York: Vintage Books, 1985.

———. *Kimono: Fashioning Culture.* New Haven and London: Yale University Press, 1993.

Iwao, Sumiko. *The Japanese Woman: Traditional Image and Changing Reality.* New York: The Free Press, 1993.

Jenkins, Donald. *The Floating World Revisited.* Honolulu: Portland Art Museum/University of Hawaii Press, 1993.

Longstreet, Stephen and Ethel. *Yoshiwara: The Pleasure Quarters of Old Tokyo.* Tokyo: Charles E. Tuttle, 1970.

Louis, Lisa. *Butterflies of the Night: Mama-sans, Geisha, Strippers and the Japanese Men They Serve.* New York: Tengu Books/Weatherhill, Inc., 1992.

Nakane, Chie. *Japanese Society.* Berkeley: University of California Press, 1970.

Reischauer, Edwin O. *The Japanese Today: Change and Continuity.* Rutland, Vermont, and Tokyo, Japan: Charles E. Tuttle, 1988.

Scott, A. C. *The Flower and Willow World: The Story of Geisha.* London: Orion Press, 1960.

Seigle, Cecilia Segawa. *Yoshiwara: The Glittering World of the Japanese Courtesan.* Honolulu: University of Hawaii Press, 1993.

# ACKNOWLEDGMENTS

My exploration of the geisha world was a journey into the unknown in every way, and the obstacles often seemed overwhelming. But at every critical turn, someone helped point the way. To those whose lives I entered, those who shared the journey, and those who made it happen, I am indebted.

Ray de Moulin was at the heart of this project. As general manager of the Professional Photography Division and vice president of Eastman Kodak, he provided the funding and inspiration to photograph this secret world. David Biehn and Kathleen Moran at Kodak continued that support, and I am grateful.

This work could have found no better friend and ally than Jonathan Segal at Alfred A. Knopf, who with great perception, patience and good humor saved the day, again and again. Or a designer with more superb skill and discernment than Peter Andersen. Or a kindlier spirit than Ida Giragossian, whose guidance kept me on track.

It was desperately difficult to penetrate the geisha world. Alex Kerr in Kyoto, with his mastery of Japanese arts, invaluable insights and far-ranging contacts, unlocked the door. Thank you. In Tokyo, Junichi Yano at the Foreign Press Center and Mike Millard provided further leads. Bob Kirschenbaum of Pacific Press Service advised, and Ryoko Yoshida, Meredith McKinney and Kunio Kadowaki interpreted, and all became friends.

My long association with *National Geographic,* where I am a staff photographer, has given me more colleagues upon whose support I depend than I can name here. But special thanks are due to Bill Graves, former Editor, who granted me the leave of absence to do the work, and Bill Allen, his successor, who enthusiastically facilitated its completion. Tom Kennedy, Director of Photography, championed the project from the beginning, and many friends there shared their knowledge, time and expertise. Thank you, Sam Abell, Bill Allard, Sisse Brimberg, David Doubilet, Kate Glassner, Dave Griffin, Dave Harvey, Elizabeth Hillman, Chris Johns, Kent Kobersteen, Sarah Leen, Bill Marr, Kathy Moran, Nick Nichols, Connie Phelps, Susan Smith, Susan Welchman and Cary Wolinsky.

Throughout, Bob Hodierne, Charles McCarry, Michael Rudell, Dan Wasser, Susan Biddle, Betsy Frampton, Linda Creighton, Declan Haun and Frank Hunger counseled or cheered, or both. My family, Jo (a.k.a. Mom), Ed, Eulalia, Charlie, Janet, Sonya, Alison, Ashley and Lauren—Cobbs all—provided help both practical and spiritual. And I am grateful to Bob Gilka, Bill Garrett, Tom Brokaw, Cornell Capa, John Calley, Sandy Lean, the Gore family, Rich Clarkson, Sandra Eisert and Charlene Valeri, for friendship and support.

But mostly I must thank the geisha, who, defying tradition, opened their lives to me and gave their time, their stories and their most private thoughts. They prefer to remain nameless, but I have become their interpreter of sorts, and I hope I have served them well. I will never forget them, their many kindnesses and their courage.

This book was photographed with the generous support of Professional and Printing Imaging, Eastman Kodak Company.

A NOTE ON THE TYPE

The text of this book was set in Monotype Joanna, a typeface
designed by Eric Gill, the noted English stonecutter, typogra-
pher, and illustrator. It was released by the Monotype Corpo-
ration in 1937. Reflecting Eric Gill's idiosyncratic approach
to type design, Joanna has a number of playful features, chief
among them the design of the italic companion as a narrow
sloped roman.

Composed by North Market Street Graphics,
    Lancaster, Pennsylvania
Color separations by AD.VER, Bergamo, Italy
Printed and bound by CS Graphics, Singapore
Designed by Peter A. Andersen